minnesota byways

Schoolhouses *of* Minnesota

Schoolhouses

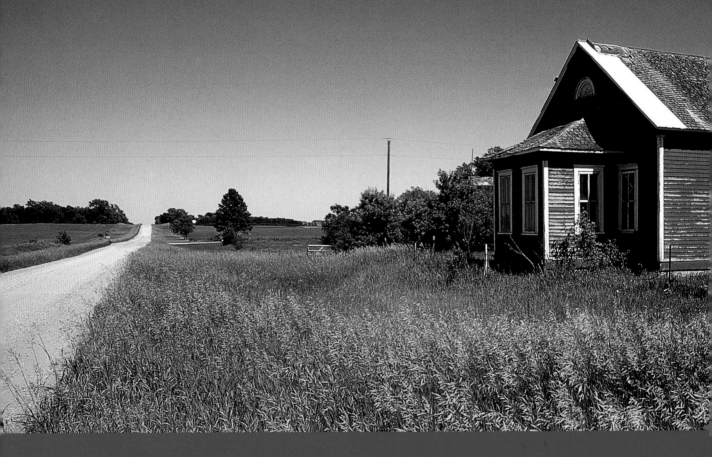

minnesota byways

of Minnesota

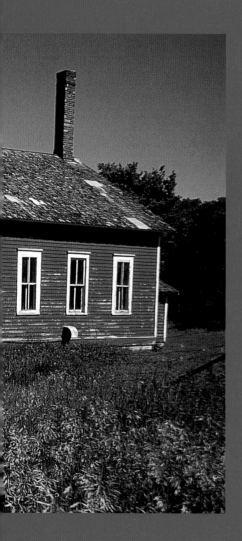

Photography by Doug Ohman

Text by Jim Heynen

MINNESOTA HISTORICAL SOCIETY PRESS

minnesota byways

Barns of Minnesota
Churches of Minnesota
Courthouses of Minnesota

Publication of this book was supported in part by the Elmer L. and Eleanor J. Andersen
Publications Endowment Fund of the Minnesota Historical Society.

www.mhspress.org

The Minnesota Historical Society Press is a member
of the Association of American University Presses.

Manufactured in China by Pettit Network, Inc.,
Afton, Minnesota

Book and jacket design by Cathy Spengler Design

10 9 8 7 6 5 4 3 2

♾ This book is printed on a coated paper manufac-
tured on an acid-free base to ensure a long life.

Photograph, pp. 2–3: District 48, Rose Hill Township,
Cottonwood County, 1900

"Amanda's Recipe" on p. 20 is used with permission
of Amanda Lopez and her mother.

International Standard Book Number
 13-digit: 978-0-87351-548-1 (cloth)
 10-digit: 0-87351-548-X (cloth)

Library of Congress Cataloging-in-Publication Data

Ohman, Doug.
Schoolhouses of Minnesota / Photography by
Doug Ohman, text by Jim Heynen.
 p. cm. — (Minnesota byways)
ISBN-13: 978-0-87351-548-1 (cloth : alk. paper)
ISBN-10: 0-87351-548-X (cloth : alk. paper)
 1. Schools—Minnesota—Pictorial works.
 2. Schools—Literary collections.
 I. Heynen, Jim, 1940–
 II. Title.
 III. Series.

LA310.O46 2006
371.09776—dc22

 2006006786

Schoolhouses *of* Minnesota

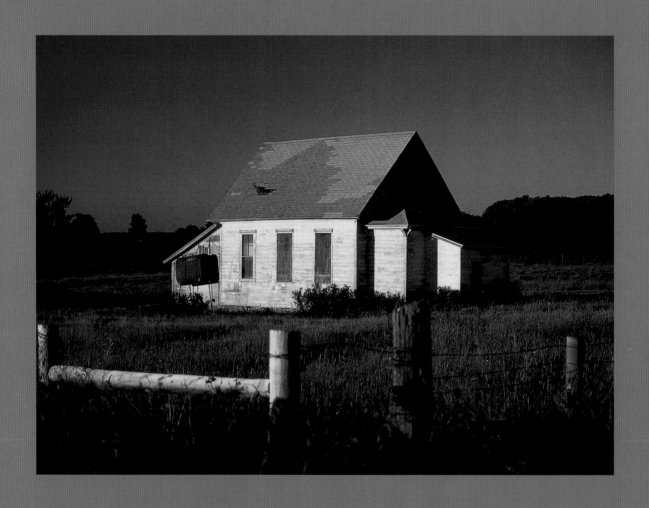

District 82, High Forest Township, Olmsted County. The district was organized in 1859.

Dedication

To Ena, the nineteen-year-old one-room schoolhouse teacher, who had only one year of college and two summer schools, who came to school early to make lesson plans for all eight grades in all subjects. To Ena, who didn't like math or biology but loved music and art and stories, who wore dresses with flower and bunny prints, who read aloud after lunch while the first graders slept on their rugs and the eighth graders passed notes, who read and read and read while the clock moved past fourth-grade math time, past eighth-grade biology time, past history and geography, into the distant worlds of *My Friend Flicka*, *Black Beauty*, *Little Women*, and *The Bobbsey Twins*, on and on until it was time to clean up the school together for the reward of art and more stories. To Ena, who cried when the older students sassed her, who gave merit slips to those who read books, who asked the bigger kids to teach the little kids math and biology, who started each day with songs, who drew pictures on the blackboard with colored chalk, who smiled and read and read and read to children who went home happy, believing that learning was like this. To Ena, whose students had little math or biology but who had much love for songs in the air, for pictures in the mind, and for words on the page. To Ena, whose students would read their way through more years of college than she ever knew.

JIM HEYNEN
Saint Paul, Minnesota

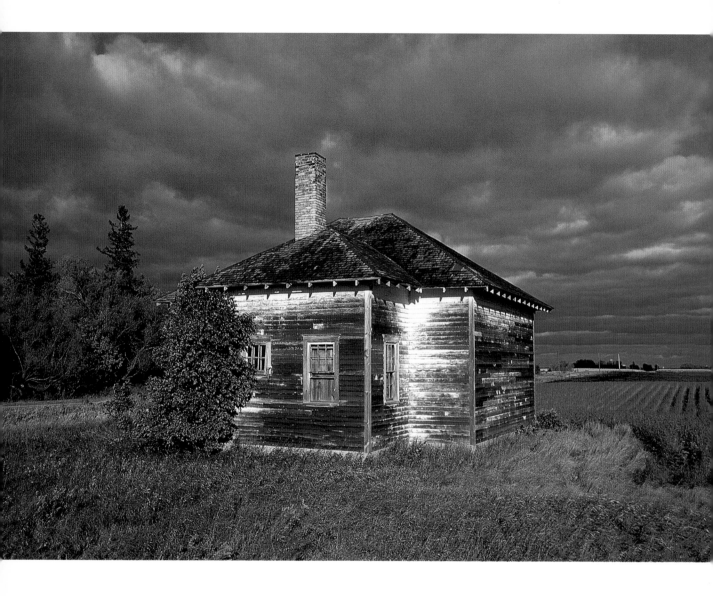

ABOVE District 136, Ashley Township, Stearns County, 1888. The school, known locally as "Gray's School," was organized by a Mr. Gray in 1888.

RIGHT District 106, Maple Leaf School, Dexter Township, Mower County, 1891. Note the eight-pane transom window above the doors.

NEXT PAGES Student desks, Wangen Prairie Lutheran School, Leon Township, Goodhue County, 1879

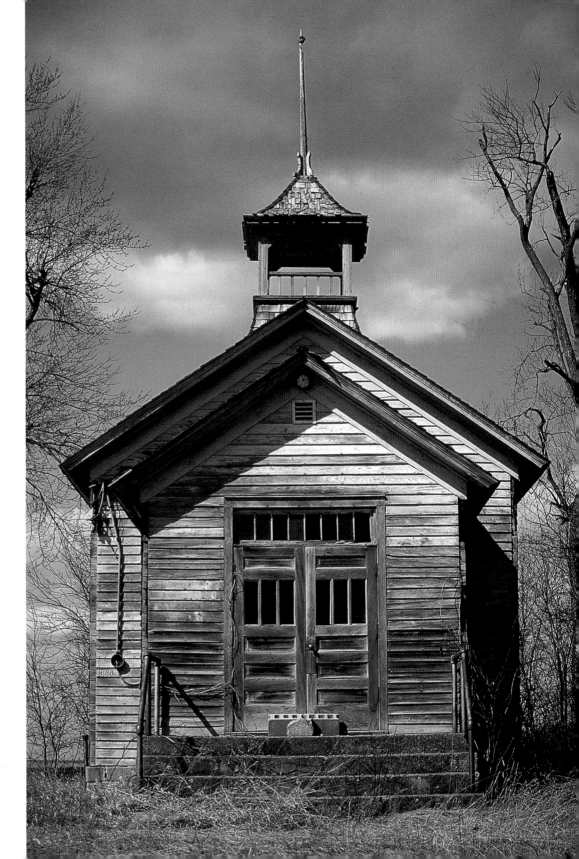

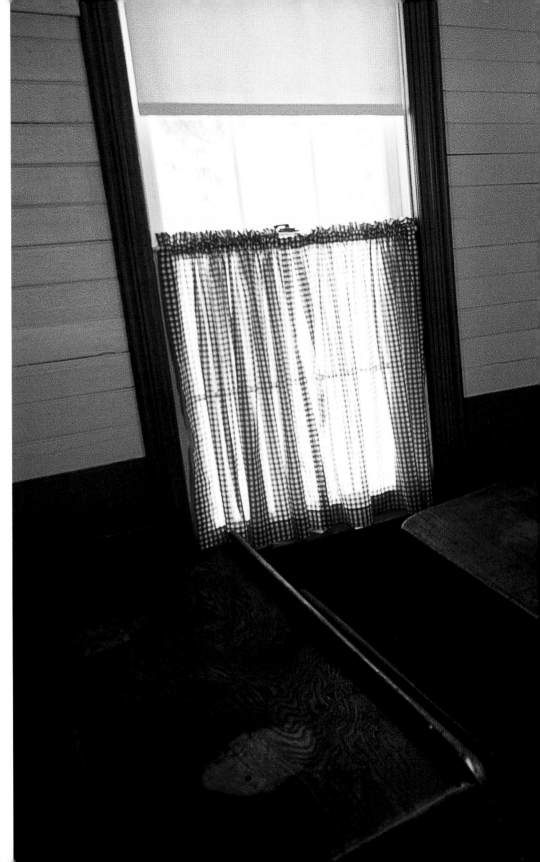

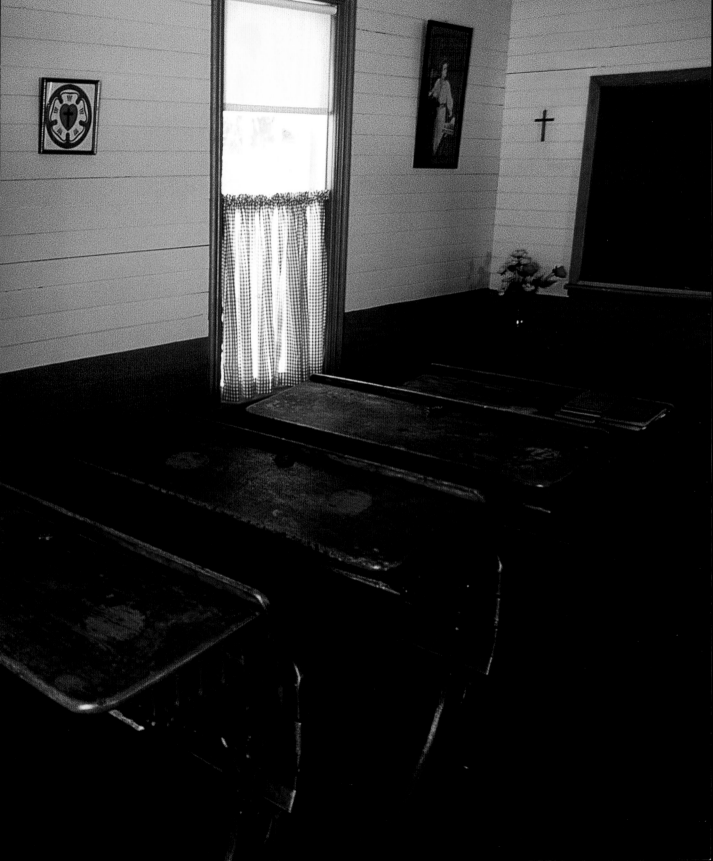

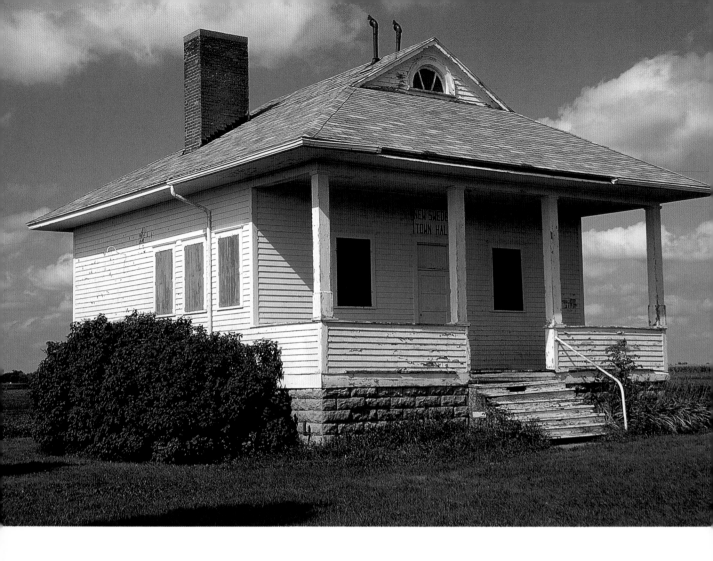

ABOVE District 6, New Sweden Township, Nicollet County

BELOW District 81, Timothy Township, Crow Wing County, 1905. Known locally as the Swanburg School. Many schoolhouses have been reused as township halls.

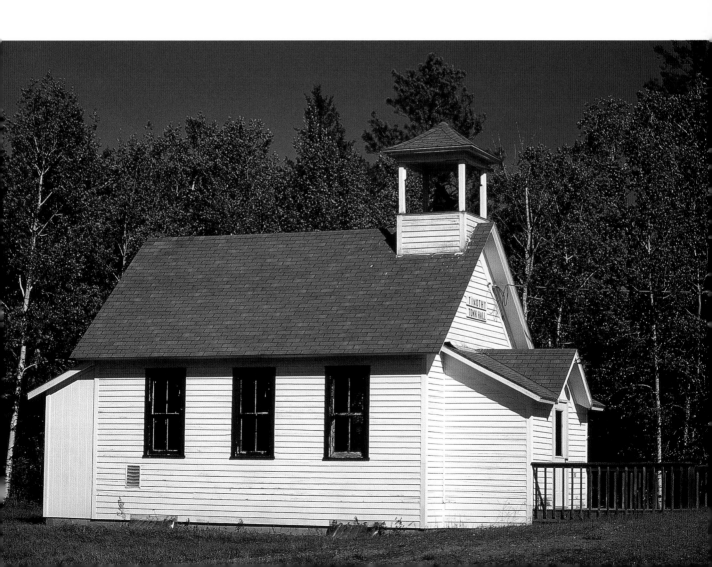

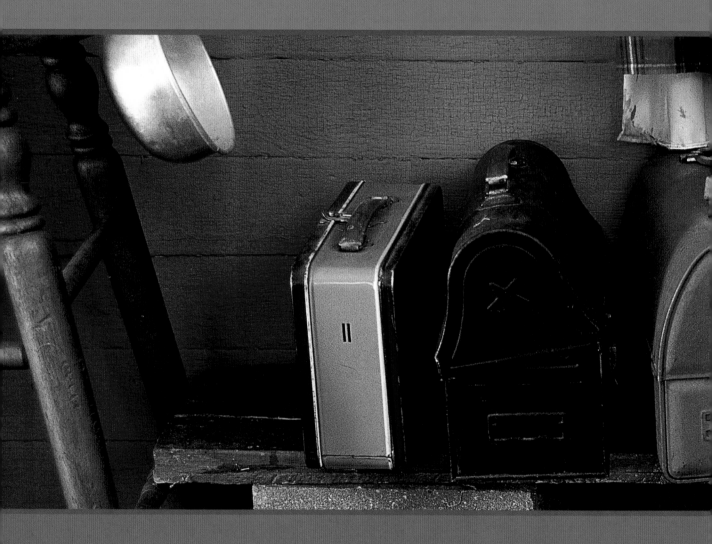

AaBbCcDdEe

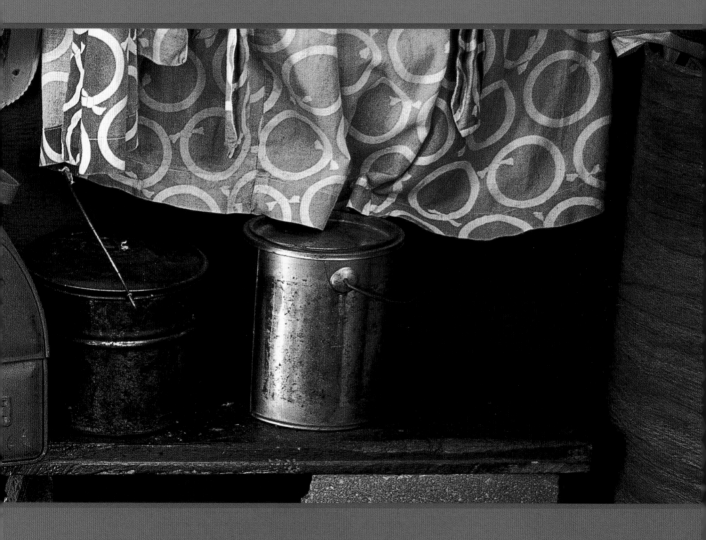

Thirteen Ways of Looking at a Schoolhouse

(With apologies to Wallace Stevens)

I

On the flat windy prairie,
The only thing not moving
Was a small red schoolhouse.

II

The picture had three minds:
A church with its blue steeple,
A schoolhouse with its silver
 flagpole,
A girl with her yellow pony.

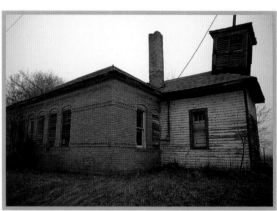

III

The schoolhouse grew from the
 snowdrifts,
A bride in a white dress.

IV

Children and a playground
Are many.
Children and a schoolhouse
Are one.

V

The teacher did not know
Which she preferred—
The sound of the school bell
Or the child's laughter
Just before.

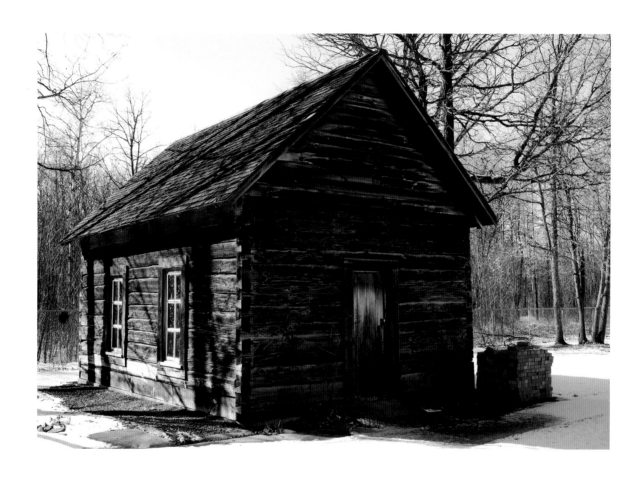

LEFT District 14, Webster School, Comfort Township, Kanabec County, 1899. The schoolhouse was built in 1899, replacing a log schoolhouse (above) that now is part of the Kanabec County Historical Society.

ABOVE Original Webster School, constructed of logs with the chamfer-and-notch technique sometimes called the half-dovetail.

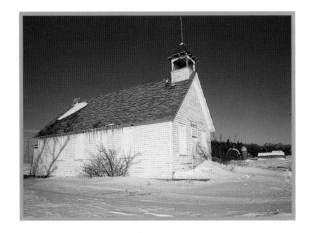

VIII

Knowledge walks about
On small, shaky legs.
The schoolhouse knows
It is the reservoir from which
Understanding drinks.

IX

When they tore the old
 schoolhouse down,
The land where it stood
Wheezed and sputtered.

X

At the sound of singing
From the small schoolhouse,
In the neighboring field
The old gray mule
Galloped in harmony.

VI

Gray clouds churned on
 the horizon,
With the face of a monster,
Wind and the promise of wind.
The schoolhouse rattled
 its windows,
Ready for the old charade.

VII

O principals and superintendents,
Why do you study graphs and
 test scores?
Can you not see the schoolhouse
Dance in the moonlight of learning?

18

ABOVE District 72, Reno Township, Pope County, 1887. The school closed in 1936, but the new roof should help keep this country school standing for years to come.

RIGHT District 17, Burschville Township, Hennepin County, 1894

XI

A stranger rode through the

 bright countryside

In a black Buick.

Their shadow against the cornfield

Resembled a deserted schoolhouse.

XII

The schoolhouse chimney

 is smoking.

The children must be studying.

XIII

It was recess all afternoon.

It was raining

And it was going to rain.

The windows framed

The assembly of sadness.

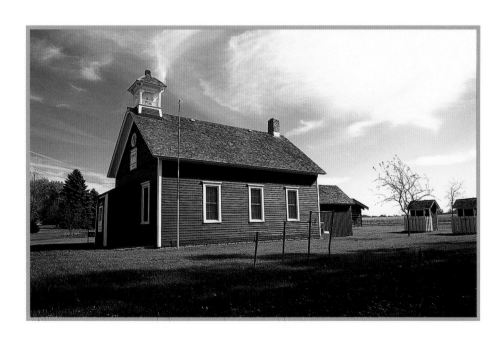

Second Grade Bulletin Board

THIS IS <u>AMANDA'S</u> RECIPE

1. Put it in the oven and cook it.
2. Take it out of the oven and eat it.
3. I like to put salt on it.

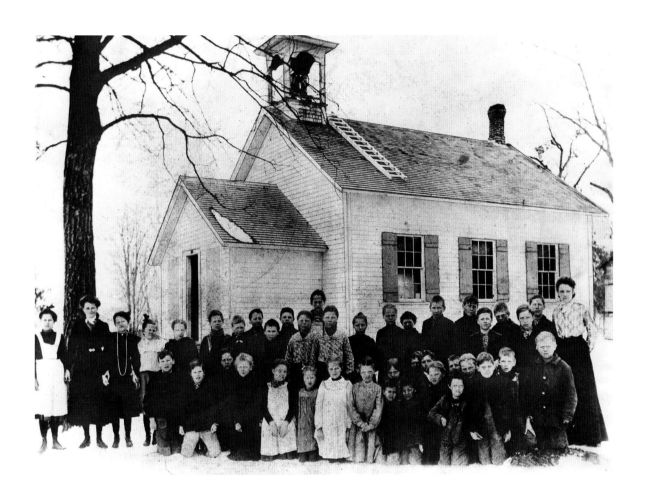

ABOVE Unidentified one-room schoolhouse, pupils, and teacher, 1910 (MHS Runk Photograph Collection)

Lunch Pails

At one time the school hallway was a library of lunch pails. Or more an art gallery of heroes and heroines: Roy Rogers next to Mary Poppins, Betty Boop next to Donald Duck and Charlie Brown. There's a real boy's line with Hopalong Cassidy, the Hardy Boys, Spider-man, Superman, Batman, and G.I. Joe. But there's Bettie Page and Hello Kitty. Somebody has his father's black lunch-bucket with its wire thermos holder, and a few pails have no pictures: stripes, tablecloth plaid. There's Barbie Pink Roses next to E.T. and the Incredible Hulk. The faces and figures change with the year: Hot Wheels, the Gremlins, Roger Rabbit, Tinkerbell, Pacman, Scooby-Doo, and Pokémon. Look: are those the Waltons on that lunch pail, and the Beverly Hillbillies on that one, right next to the Muppets? There are frilly pink lunch pails and brazen space-age ones, and Daffy Duck goofy ones. This isn't a library. It isn't an art gallery. It's more of a smorgasbord.

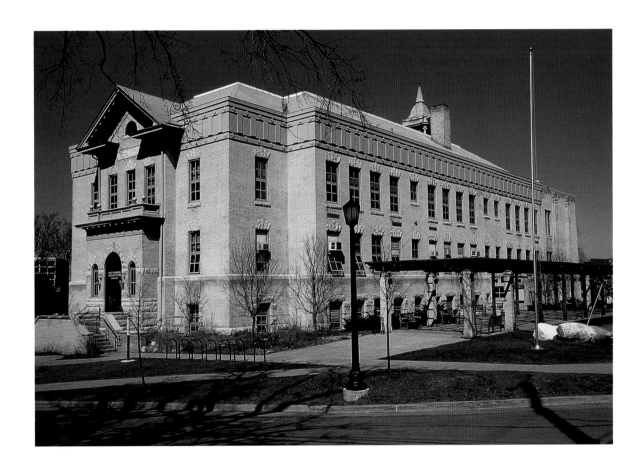

LEFT In earlier times syrup buckets were often used as lunch pails.

ABOVE Pratt School, Prospect Park neighborhood, Minneapolis, Hennepin County, 1898. It is the oldest existing public school in Minneapolis.

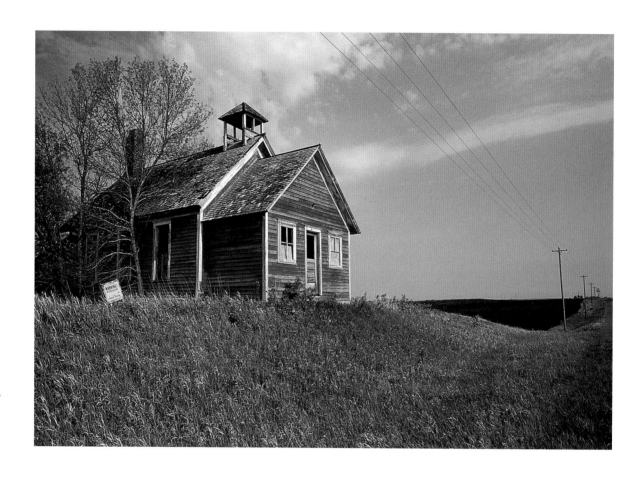

ABOVE District 35, Lemond Township, Steele County, 1880s. The school district was organized in 1860 and the schoolhouse, known locally as the Schmanski School, was built in the 1880s.

One-acre School Ground

(With apologies to Gerard Manley Hopkins)

Glory be to God for dappled things on the one-acre school ground!

For grass and dandelions, for sunflowers and milkweeds!
Glory be to God for poison ivy hiding in the ditch!

Praise the intricate world
of clover and honeybees,
of butterflies and box elder bugs.

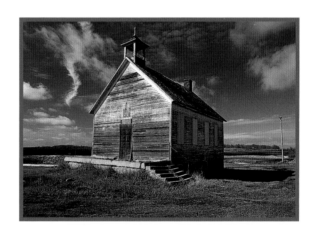

Remember the worn softball
diamond with its round farm-disk
bases.

Thank the grasshoppers for
"spitting tobacco" in the hands
of children who grip them.

Trust the laughter in that world of no hiding, where anyone's joke
is everyone's joke, where anyone's fool is everyone's fool and kindness
by one is kindness to all.

Celebrate the world where the actor is audience and the audience actor,
where everyone knows and there's nowhere to go.

ABOVE District 54, Fergus Falls Township, Otter Tail County, 1874. Known locally as the Sunshine Hill School.

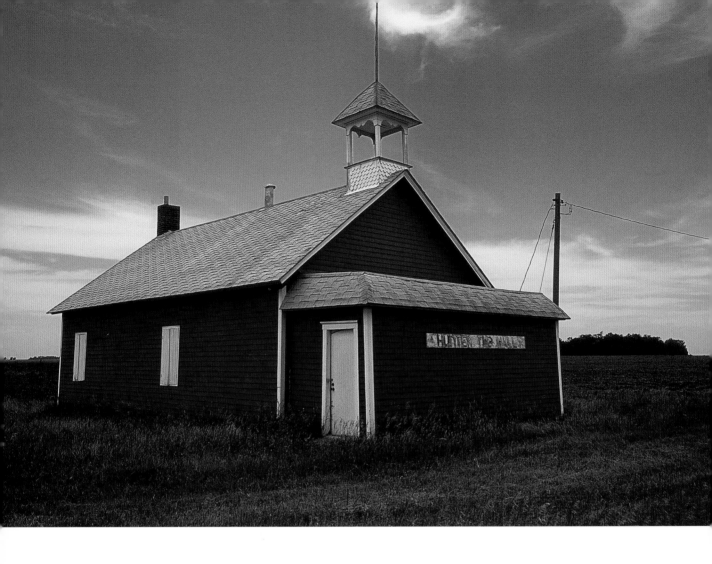

ABOVE District 133, Hunter Township, Jackson County. The schoolhouse is now used as a township hall.

RIGHT District 27, Terrace Township, Pope County, 1900. The school district was organized in 1869 and closed in 1945. Today the schoolhouse is located in a National Historic District.

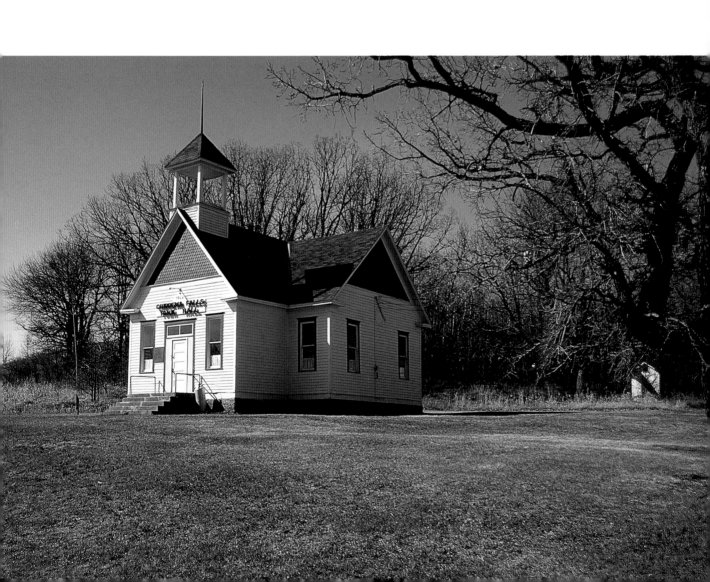

District 38, Mantorville Township, Dodge County, 1885. The schoolhouse closed in 1957 and in 1964 was moved to Mantorville from Ashland Township. Today it is part of the Dodge County historic park in Mantorville.

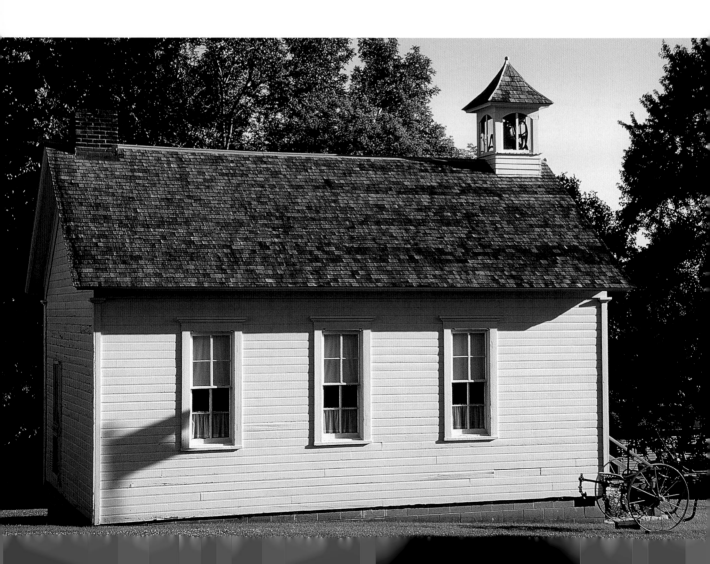

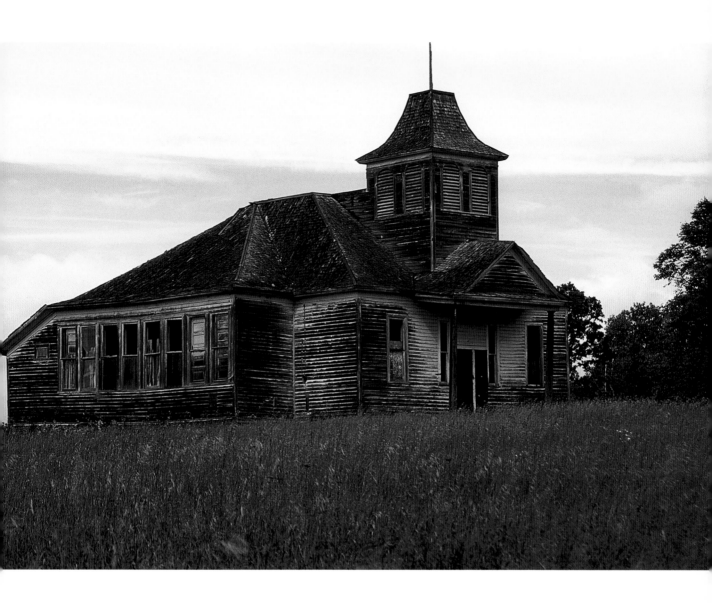

ABOVE District 8, Kimberly Township, Aitkin County, 1892. The school closed in 1961 after the district was consolidated with Aitkin.

NEXT PAGES Maple Township, Cass County

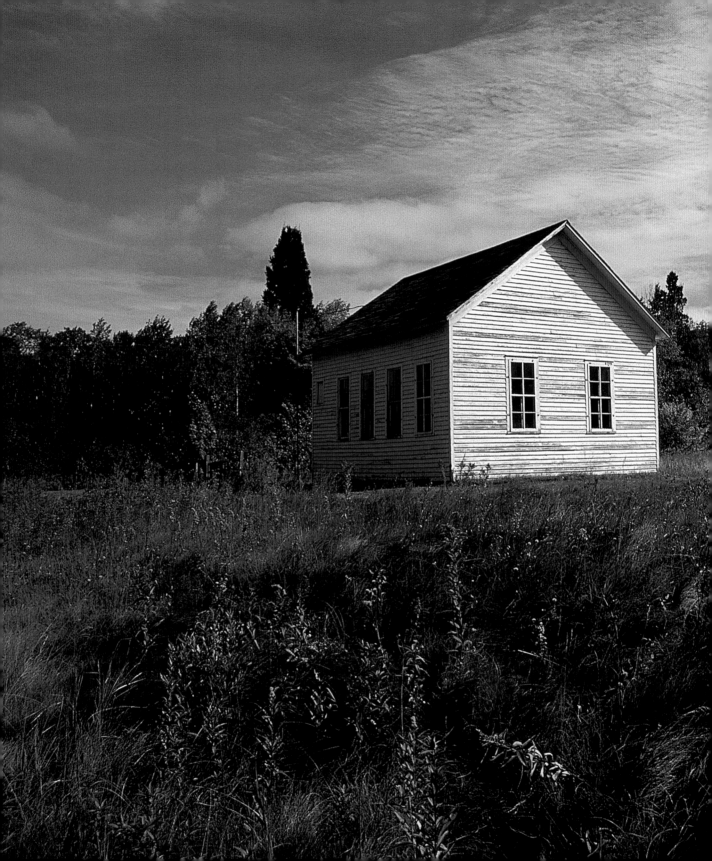

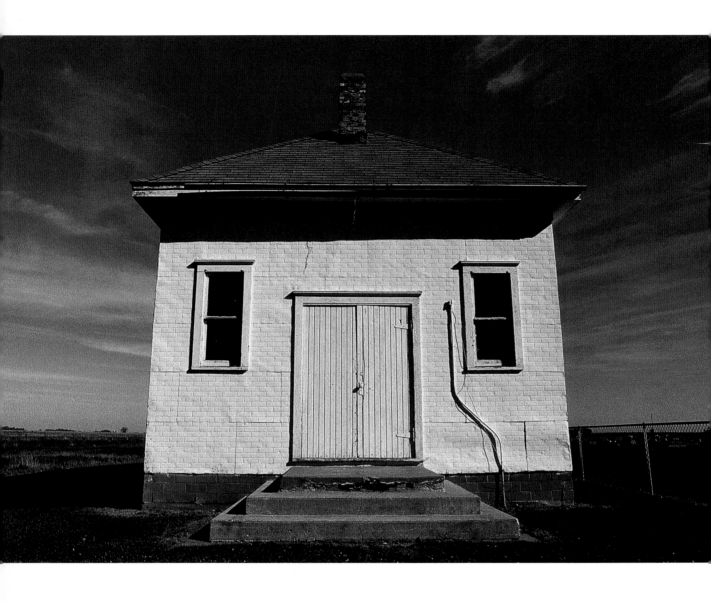

ABOVE St. John's Lutheran School, Bismarck Township, Sibley County

RIGHT District 54, Fergus Falls Township

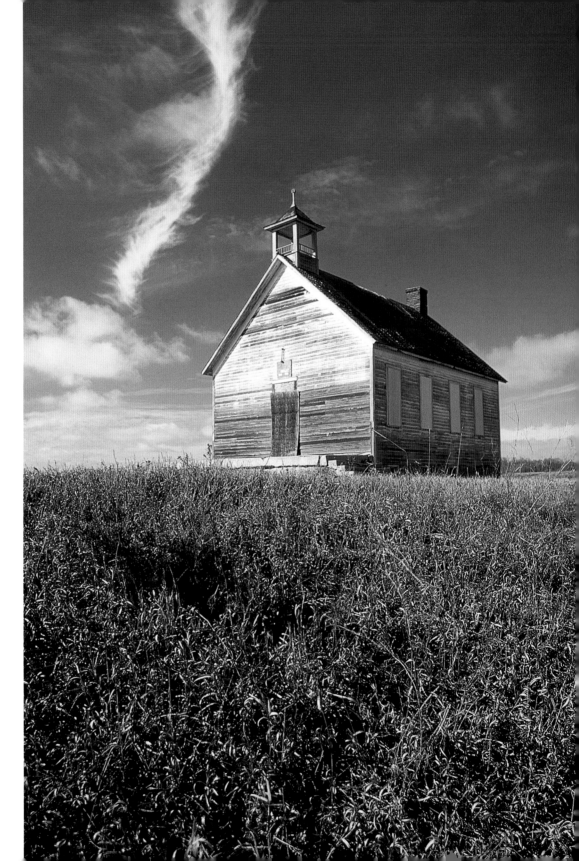

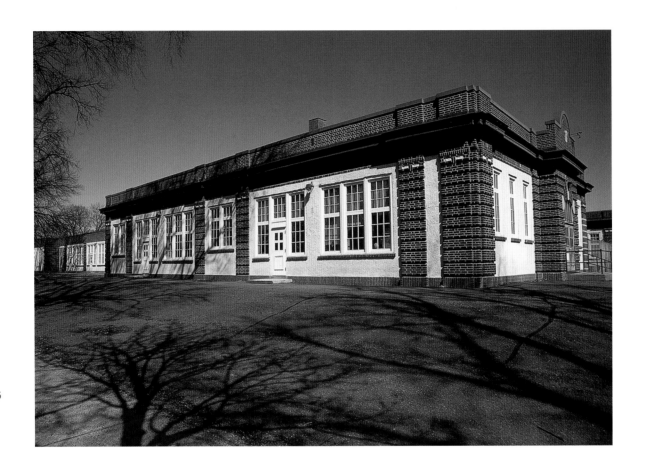

ABOVE Hiawatha Community School, Minneapolis, Hennepin County, 1916

RIGHT District 13, Artichoke Township

New Kid at School

"You see that new girl? You see how she has her hair all combed back with that granny clasp on it? Didn't that go out of style like a hundred years ago?"

"Yeah and did you hear the way she was talking to the principal, sounding like Miss Manners or something? I wanted to gag."

"And she smiles like that what's-her-name ice skater. You know, Nancy Kerrigan. She smiles like Nancy Kerrigan."

"She smiles like a picket fence."

"Exactly."

"If I had long toes like hers, I'd wear shoes that would cover them."

"I wonder who poured her into those jeans?"

"I don't know, but if she stopped moving those flabby hips she'd probably turn into concrete."

"Oh, come on, everybody, don't be so mean. I'll bet it's hard being the new kid at school. We should be nice to her."

"Whatever."

How to Kiss a Flagpole

Almost all kids are told not to kiss a flagpole in midwinter. The following advice is for those special few who can't help but wonder, WHY NOT?

1. Plan your flagpole kissing for the third week in January when temperatures are most likely to register below zero. A brisk north wind will enhance the flagpole-kissing experience but is not essential if the mercury has fallen to minus twenty or lower.

2. It is best to have the flag flying at full or half-mast. The sounds of a flapping flag will muffle the sounds you'll make once your lips and tongue have established contact with the freezing flagpole.

3. If possible, kiss your flagpole after a snowstorm that left a foot of snow. This way, your freezing feet will distract you from the fact that your lips and tongue are welded to the flagpole.

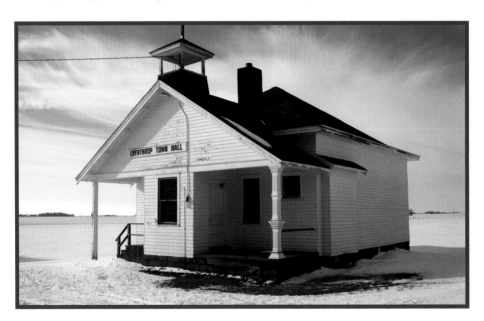

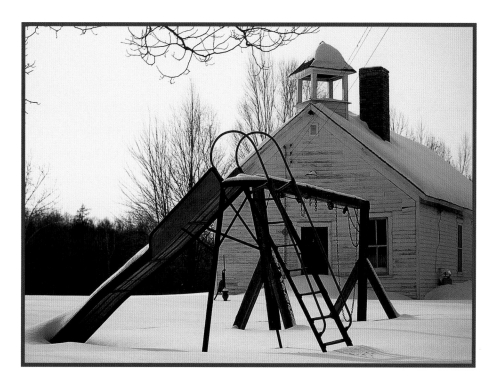

4. What is the optimum time of day for flagpole kissing? Wait until the morning bell has rung and everyone else is inside. This will guarantee a sustained fifteen-minute flagpole kiss before anyone misses you. Then the real excitement begins. They'll try everything: soothing talk, encouragement to breathe really hot air, and cups of warm water poured continuously on the area of contact. Ideally, the fire department will come with sirens blaring and then use blowtorches to heat the flagpole below and above the kiss-point.

Benefits? You will be the center of attention for the day, and, although you may not have a full set of taste buds as an adult, you'll have a good story to tell your own children.

LEFT District 27, Leenthrop School, Leenthrop Township, Chippewa County. Note the decorative column on the porch.

ABOVE District 74, Danforth School, Danforth Township, Pine County, 1906. The schoolhouse was used for church services on Sundays until a proper church was built in 1986.

Somersaults

When things in school get too fancy, the walls too clean, the landscaping too precious, when teachers get stricter for no good reason and everyone thinks their clothes are the latest, when arrogant snobs try to rule the roost, when history gets boring and math gets tough, and when your best friend decides that you're a waste of time, the only solution is to go outside and do what your great-grandparents and grandparents and parents did—the only solution is to go outside and somersault your troubles away.

Just run outside and do it. Don't think about form. Don't think about grass stains or mud stains. Don't worry about hairdos or whether you'll look like a lopsided tire rolling across the school grounds. Find a wide-open space, put your hands behind your neck or grab your knees—whatever works for you—nothing fancy, just a good old-fashioned somersault, but just do it! Somersault until your joints are loose. Somersault until you're so dizzy that when you stand up the whole spinning world makes sense again.

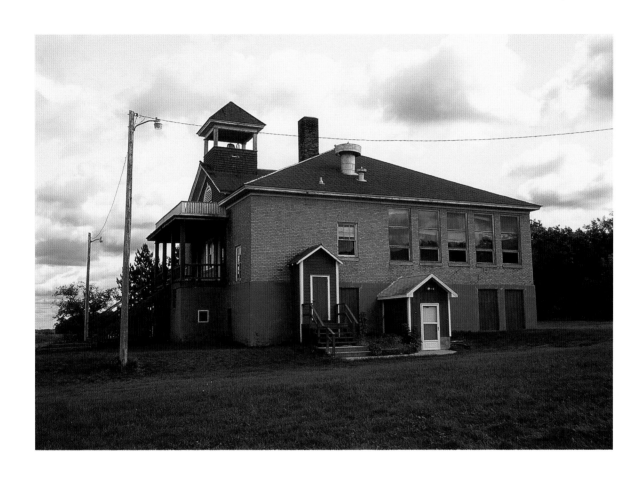

ABOVE Gully Township, Polk County

Straight Lines

Schools like straight lines. Schools want students to write in straight lines, to line up in straight lines, and to stay in line. For schools, trouble starts with the swerves and curves. Even those teachers inclined toward circles know that the school wants the desks to be put back in straight lines at the end of the day. School rules are straight, and bending them spells trouble. Buses know what schools want when they park in a straight line along the curb. School architects know that schools prefer to look like rectangles and boxes—windows in straight rows, straight as the chalk line on the baseball field, straight as the flagpole. Schools like to have their curtains at half-mast, level to the eyes of the passerby, level as water, level as the straight shooter who levels with you. The students who know what schools want stay out of trouble by going straight home after school. Good straight-line schools

send squiggly students straight to the principal's office. Listen, people, you're in school: straighten up.

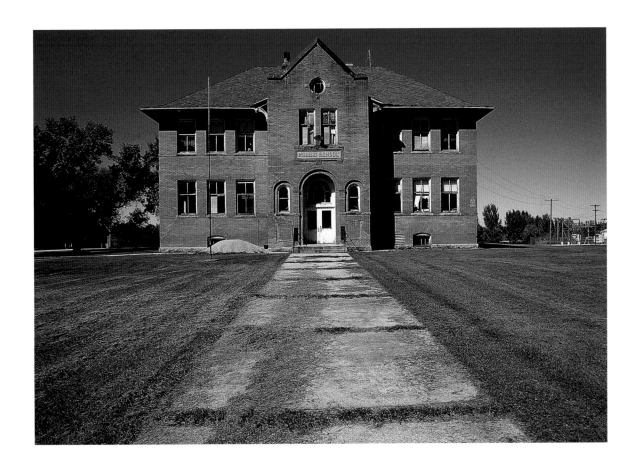

ABOVE District 11, Donnelly Township, Stevens County, 1905. Like many small-town schools affected by consolidation, the Donnelly School closed in 1971.

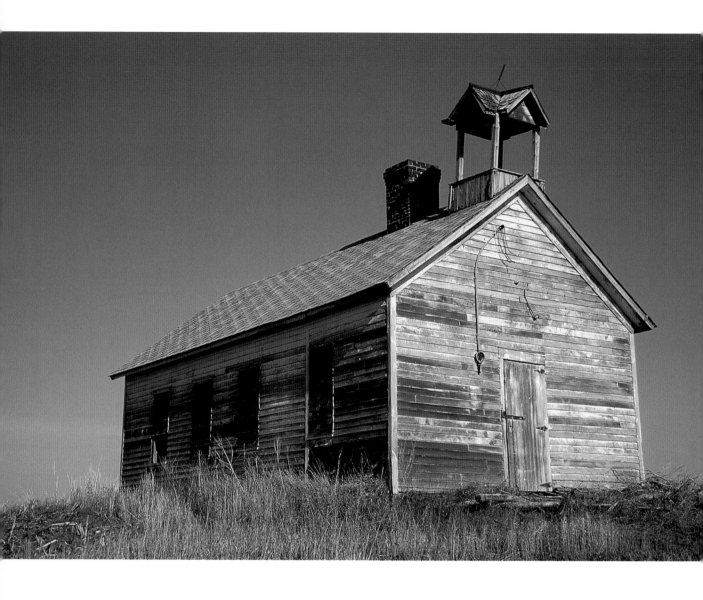

ABOVE District 94, Blue Mounds Township, Pope County, 1902. The school closed in 1936.

RIGHT District 106, Maple Leaf School

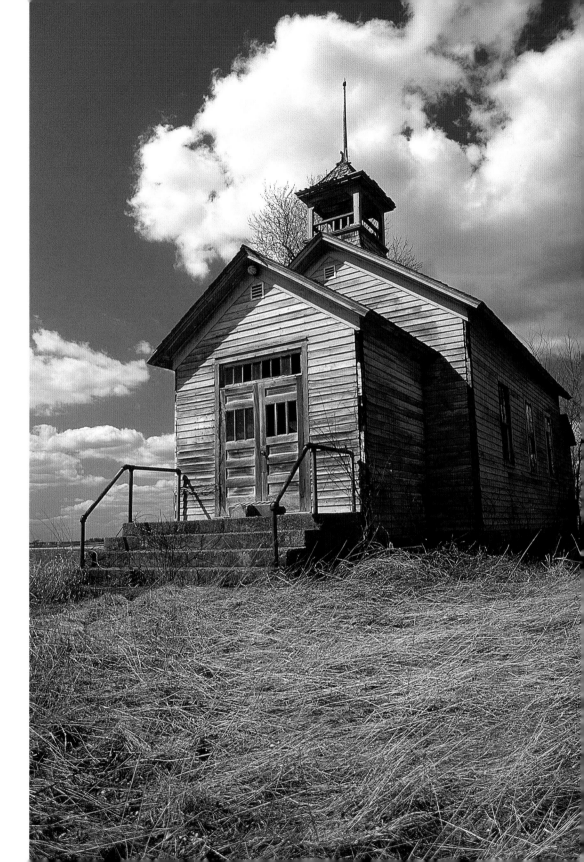

BELOW Owatonna High School, Owatonna, Steele County, 1921, National Register

RIGHT Pratt School, Prospect Park, Minneapolis

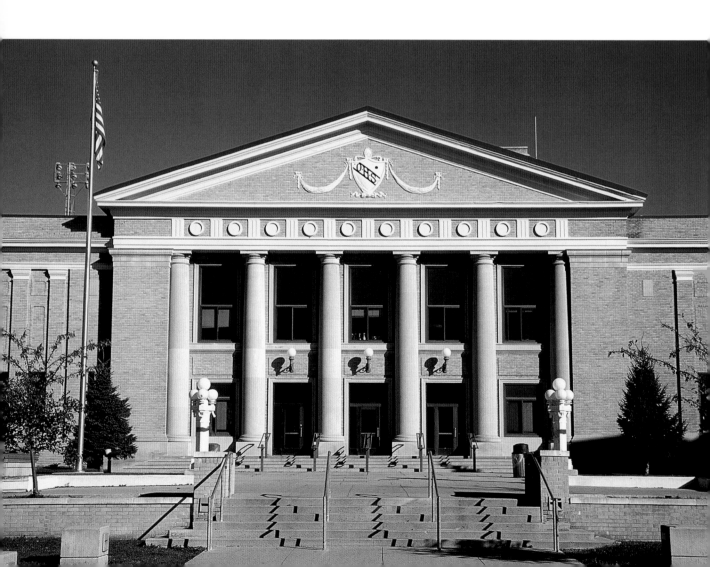

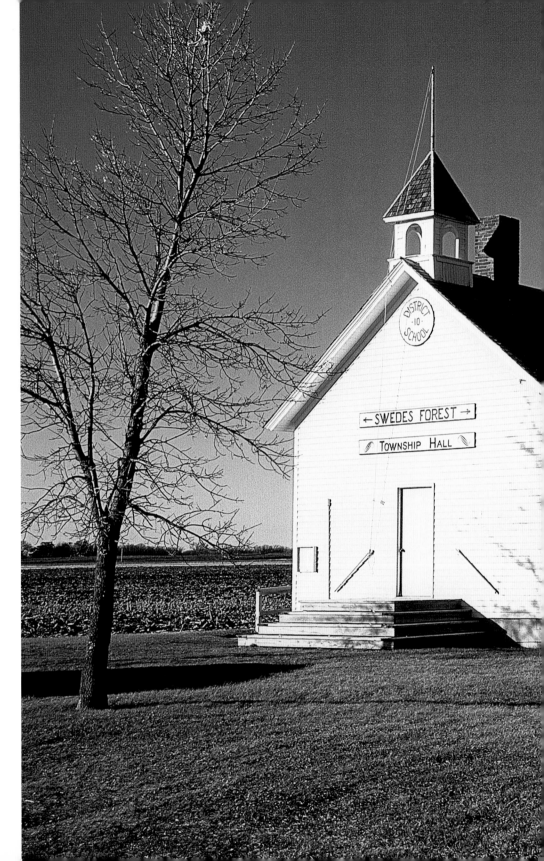

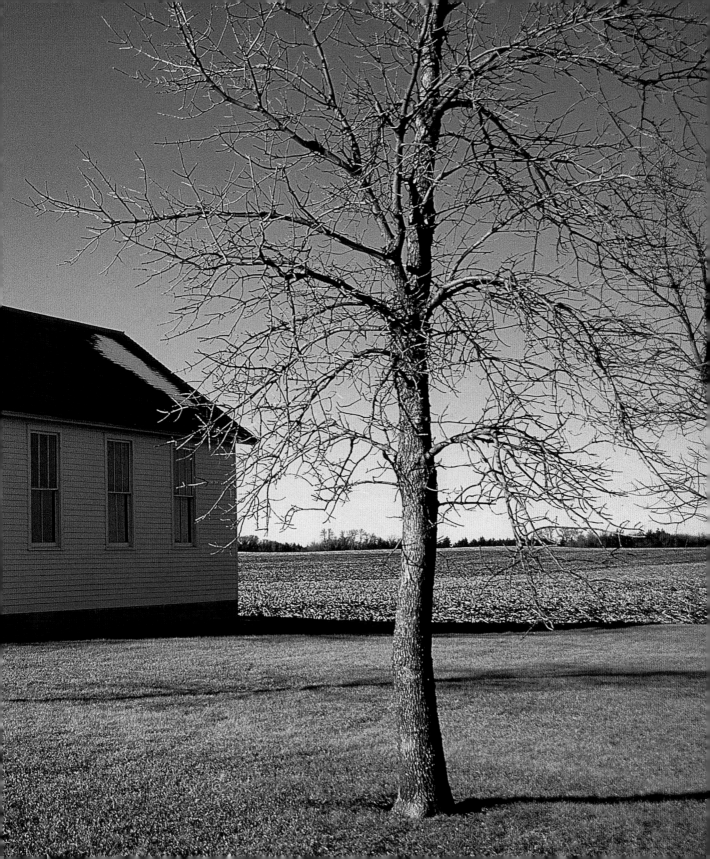

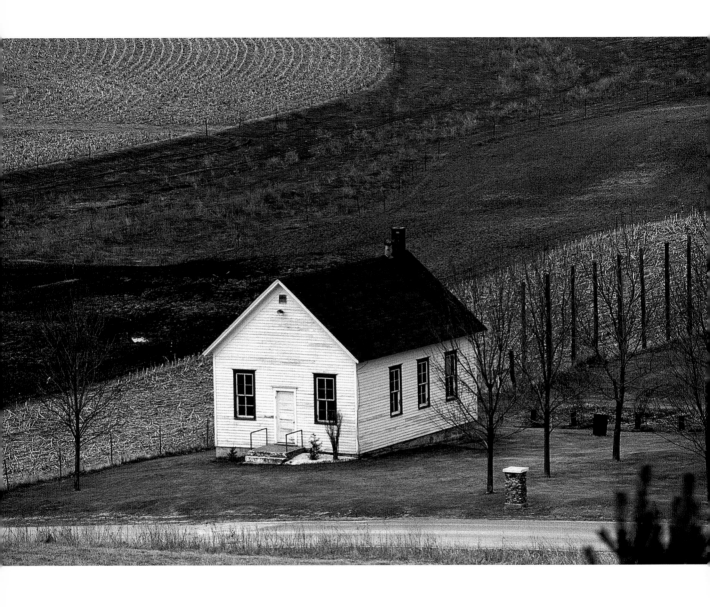

District 10, Swedes Forest School, Swedes Forest Township, Redwood County

LEFT District 32, Belvidere Township, Goodhue County, 1875. The school district organized in 1869.

BELOW Bejou Township, Mahnomen County

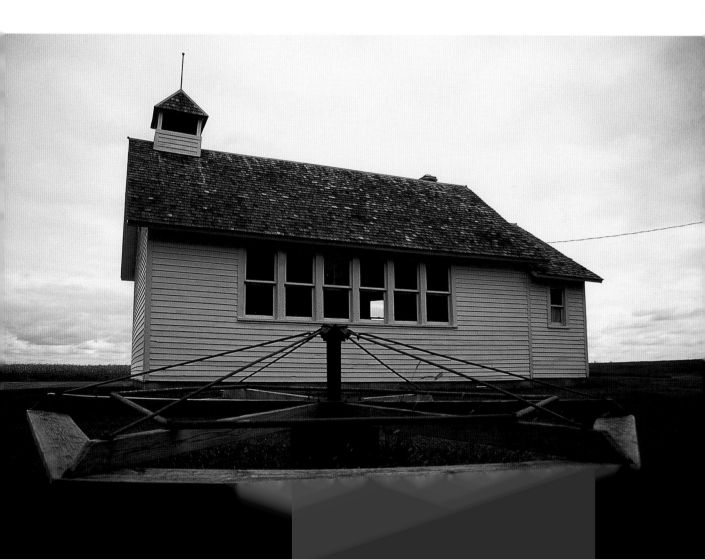

m \mathcal{N} n

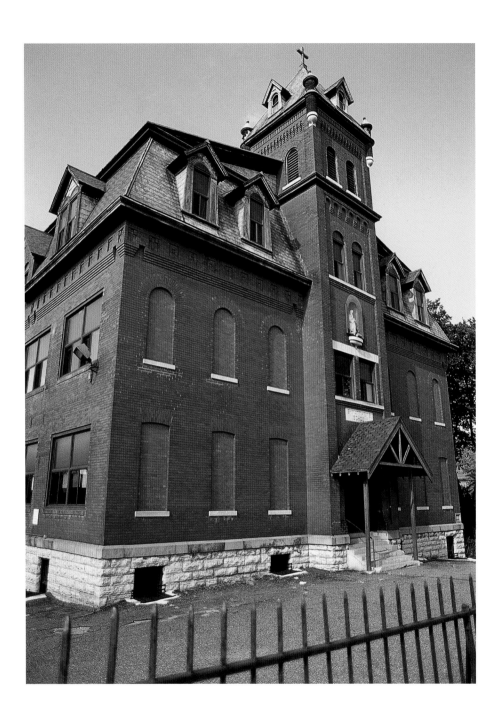

Church Schools

What about these schools that look like churches, the cross on top, and the bell cupola perched like a modest steeple? The bell does not sound like a church bell, and it does not toll for Sunday clothes and music. This bell tolls for the ordinary stuff of arithmetic, geography, spelling, reading, biology, and social studies. But this bell does have strict orders. This bell does toll for testing and judgment. It calls for obedience and attention. It says you should behave differently here because you are different. You stay in line, you say "excuse me" and "I'm sorry." After all, you're paying tuition to be here.

It all feels normal enough going to the church school until the big basketball game against the super big public school. Maybe church rubs off on the church school kids just enough so that they say a little group prayer before tip-off. Maybe they listen carefully when the coach tells them not to swear, even if an opponent fouls them on purpose.

But somehow the cheerleaders from the other side become part of the game. During a time-out, they give this bouncy cheer:

One two three four five six seven
Our boys are going to heaven
When they get there they will say
Midwest Christian, where are they?

Maybe we are different, the church kids think. They lose the game, and even though losing is not exactly like going to hell, the taunt follows them back to school the next day. They don't work harder at basketball practice, but they do work a little harder at grammar and punctuation.

LEFT St. Matthew's Catholic School, St. Paul, Ramsey County, 1902

The Bully

The bully has an eye for weakness. He can spot the fissures in a timid kid's smile. He can detect that little quake in somebody's walk, the way the feet act as if they're not sure where they should come down next. Those feet are made for running—away from him. But it's mostly the eyes that catch the bully's eye. Fear can't hide inside the eyes of weakness. The bully sees the twitch in the eyelid, and he knows the eyes of weakness cannot withstand a long, cool stare. When the intimidated eyes look away, the bully sees a dog rolling on its back to offer its belly in a plea for mercy. The bully shows no mercy: he gives weakness a good shove and is on his way.

When the bully is not around, some kids dare to talk about him. Someday he'll meet his match, they say. One of these days we're going to nail his lunch-bucket to the floor and he'll never know who did it. Let's make up stories about how he got beat up at the county fair and went crying to his mommy. Let's just ignore him.

The bully knows what they're up to. When they emerge from their pathetic scheming, he stares them down, making their petty weaknesses ooze out of them.

RIGHT District 43, Whitney Brook School playground, Page Township, Mille Lacs County

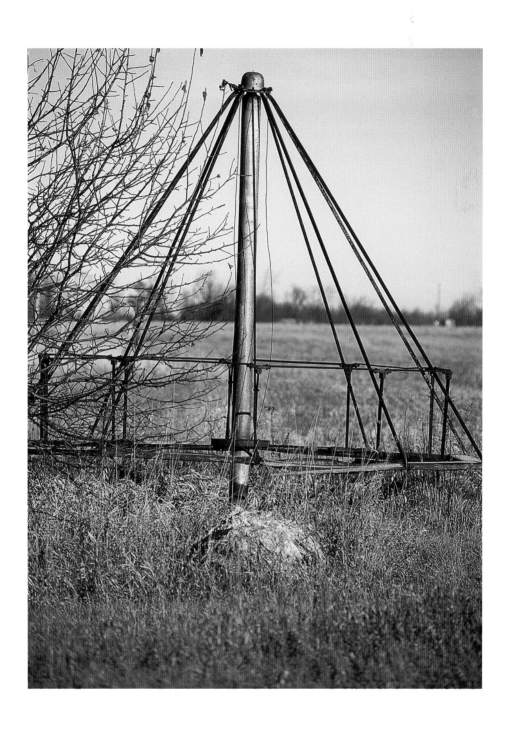

Sissies

Every school has a sissy. Parents can't keep the sissy home from school. What would they do with him? So he comes to school but looks as if he is waiting for his mother to come and button his coat and show him how to take the wrapper off his candy bar. Even a stray dog can spot the sissy. The sissy smells like tears. The sissy can't run very fast and his shoelaces are untied. Why is he always looking up so sadly that you can see the white under the pupils of his eyes? Everything about the sissy says, "Please. Don't."

But of course everybody does. They do whatever they please to the sissy. They shove and mock and laugh. They dump all the ugly stuff that's inside

themselves on top of the sissy's head. The sissy doesn't realize he's getting everybody else's problems. He thinks he's the problem and doesn't know that he is really a cleanser, that he's the magnet that pulls out all the nasty steel shavings inside the mean kids and lets them walk away feeling better about themselves.

No wonder the sissy crawls off by himself and learns to tie sixteen different kinds of knots and complete the Rubik's Cube in thirty seconds, that he learns to play piano, reads books the mean kids can't comprehend, and slowly puts all those steel shavings together into a column of fortitude that many who knew him earlier will have to face when they come to him for jobs.

ABOVE Rip Van Winkle. Teaching the American classics.

Consolidation

Bigness made us smaller.

When we think about the one-room schoolhouse, its walls get wider and wider, and the playground gets bigger and bigger. Now look at the big school: you'd think there'd be so much more room. But there isn't. You can't walk down the hall without bumping into somebody. You can't even look out a window and dream a whole sky full of daydreams because somebody else's head always gets in the way.

Look at us. The lunch lines are so long that they force the hunger right out of us. Our appetites have shrunk. Our stomachs have shrunk. The lunch lines squeeze us into the size of hot dogs. We had second and third helpings in the little school. We had good food, lots of it. We had Mom's food.

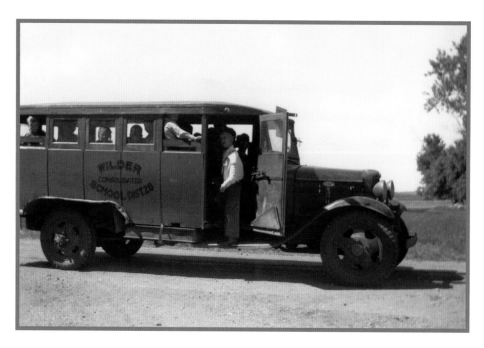

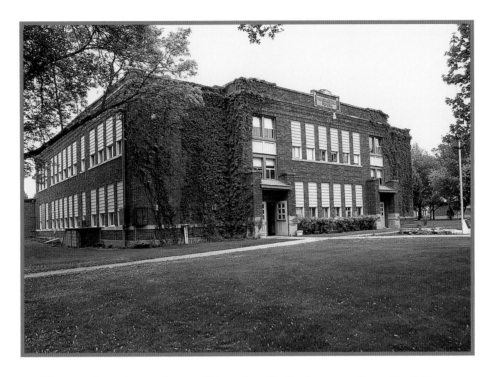

Now we have less of everything. Our fastest runner from the little school isn't the fastest runner anymore. The cutest kids aren't the cutest kids anymore. Not one of our old friends is smartest, not one is strongest, not one of us is best at anything in the big school. We were contenders at one thing or another in the little school, even if it was just drawing the nicest picture of a robin or a rainbow. We're not best at anything anymore. We're nobodies, little nobodies.

Big school? Big deal. We all grew smaller here. A lot smaller.

LEFT District 28, Wilder School bus, Ramsey County, 1941–42 (MHS Collections)

ABOVE Delavan School, Delavan Township, Faribault County, 1918. The district was organized in 1872 and the school closed in 1995. Today the school serves as an art and community center.

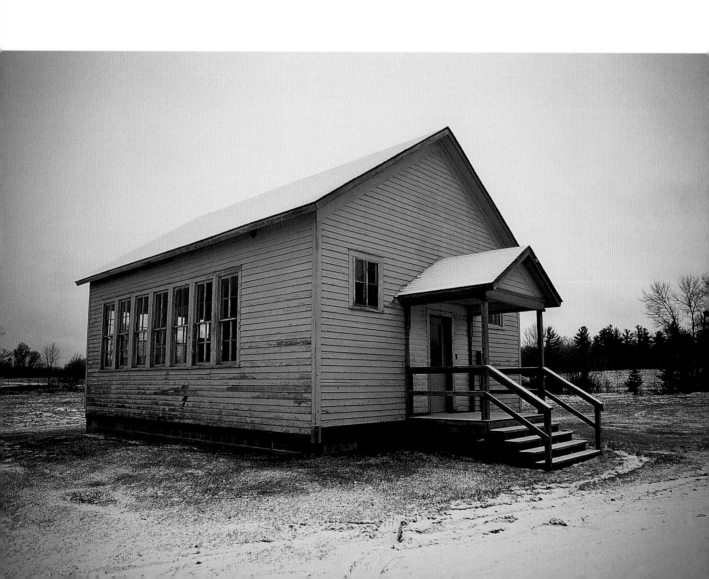

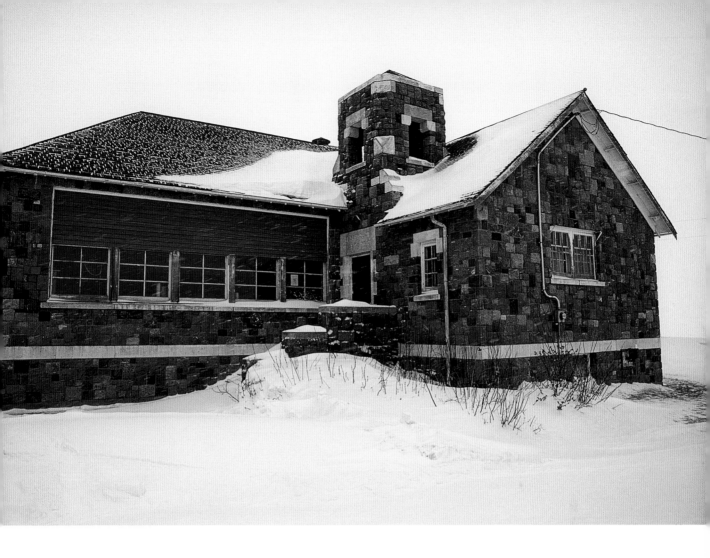

ABOVE District 121, Moland Township, Clay County, 1936. Known locally as the Gunderson School, it was built as a Works Progress Administration (WPA) project.

NEXT PAGES St. Bernard Catholic School, Cologne, Benton Township, Carver County, 1915

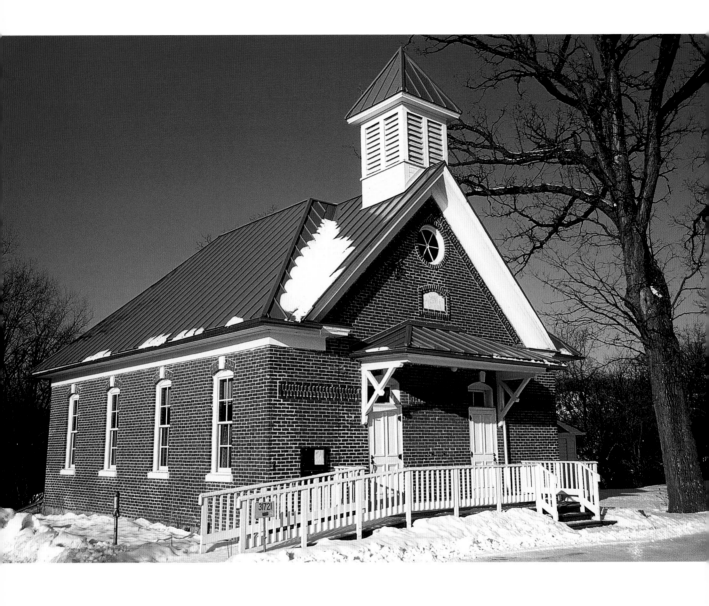

ABOVE District 20, Hay Creek Township, Goodhue County, 1889, National Register

BELOW District 18, Montgomery Township, Le Sueur County, 1900. The school closed in 1957 due to consolidation.

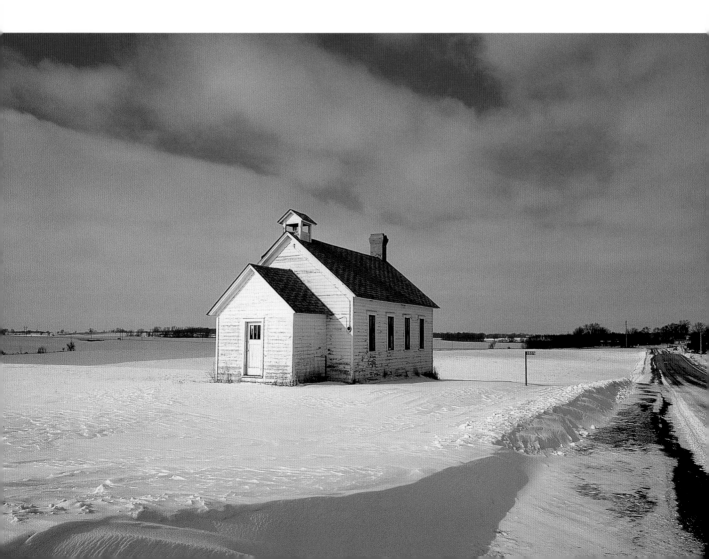

Blank Face

What's wrong with her? Look at those eyes. Did something terrible happen?

The blank-faced girl comes to school, but she's not talking. She goes to her classes on time. She opens her books. She doesn't do anything to get herself in trouble with the teacher. She doesn't do anything that would make anyone ask her a question. She doesn't like questions.

The other kids don't know what to do with the blank-faced girl. Nobody teases her because they don't know what's behind those blank eyes. She doesn't look like she's been beaten up by anybody. She doesn't complain about anything. Her grades are all right. Her face and hands are clean. Her hair is always neatly combed. She just has this blank look. Not even the teacher dares to ask her what might be behind the blankness.

Finally, after school some older girls approach her carefully. "Hey, you look kind of blank," one of them says. "What's up?"

"Nothing."

"What's going on at home?"

"Nothing."

"We'd like to be your friends. What can we do?"

"Nothing."

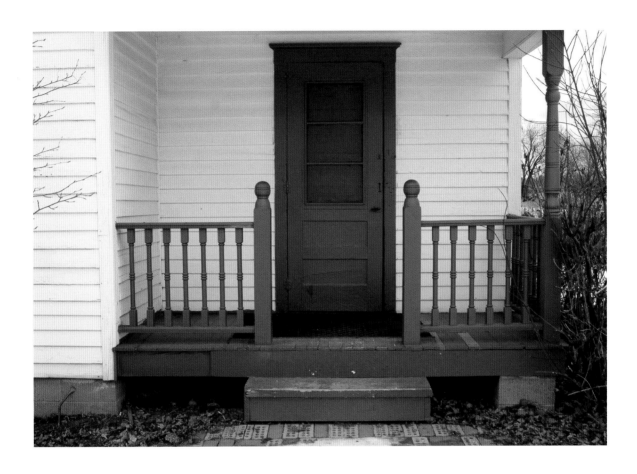

ABOVE Stoen School, Gibbs Museum School, Ramsey County, 1883. The school was moved from its original home in rural Chippewa County, near Milan.

Skipping School

Skipping school is an art. The ones who skip school without learning the art are doomed to failure and humiliation. They are losers before they skip school and even bigger losers after they get caught. They talk about how much fun it would be to skip school and then brag about it after they've done it. They are like highway speeders who drive red sports cars with big wheels and loud mufflers.

No one would ever suspect the successful school skippers. They know that it is *not* about being bold and arrogant. Skipping school is a shadow dance, a performance in magical deception. It is the sleight-of-hand concept enlarged to sleight-of-body.

You didn't see me yesterday? That's amazing: I didn't see you either; where were you?

I feel so good today I can hardly remember what we did in class yesterday; would you remind me?

I'm sorry that my mother's signature looks so much like my writing: she's very arthritic, you know, and I had to hold her poor hand while she signed the note.

Isn't life amazing: where did yesterday go anyhow?

Some would say that learning the art of skipping school is life preparation. It is said that some school skippers become teachers who can spot potential skippers of the next generation and head them off at the pass. Supposedly, some succeed at car sales or real estate. And word has it that some school skippers actually become bank presidents. Others, of course,

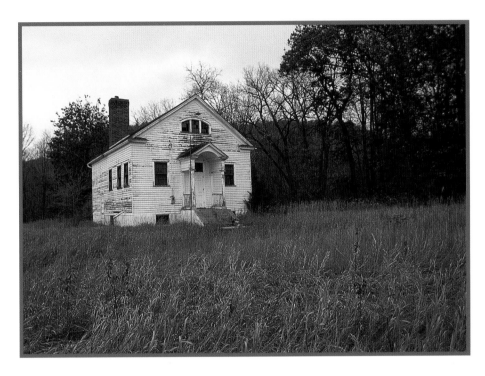

find that the art of school skipping prepares them for nothing more than punching a clock as short-order cooks in the local greasy spoon for the rest of their lives.

What about all those good people who never dream of skipping school? They usually go on to fit comfortably into the community. They're like a ship's ballast, keeping the big ship steady—and the world needs them to fill all the empty spaces.

ABOVE Rushford Township, Fillmore County

Snow Days

How could a blizzard with such needle-point sleet and fence-bending winds wear such a friendly face in the morning? "District 3—all schools closed until further notice; District 9: no school; No school today in all of Lyon Township. St. John's, no school."

No school! No school! No school!

And outside: not a blanket of snow, not something to sleep under, not something to hold you back, not something to bury you or hold you in captivity. Instead, a wonderland of glistening white setting you free in every direction! Snow to dance on and plow through! Snow to throw at people or to build snowmen and forts with! Snow to play fox and geese in, snow to toboggan and ski on. Snow for sledding down steep hills. Snow to eat!

For an hour or so.

Then frozen fingers, wet socks, runny noses, chapped lips, aching muscles—all leading to heaps of wet clothes in the porch, snow melting on the clean floor, tracks in the kitchen. Adults screaming. Kids fighting.

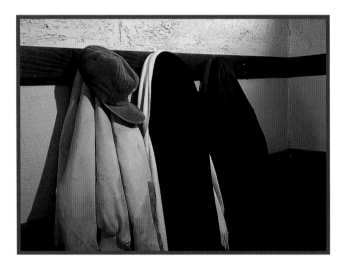

Hot chocolate ends the bedlam for fifteen minutes. And then what? A thousand-piece jigsaw puzzle? No thanks. Knitting? Are you kidding? Embroidery? You can't be serious. I know: Let's play school.

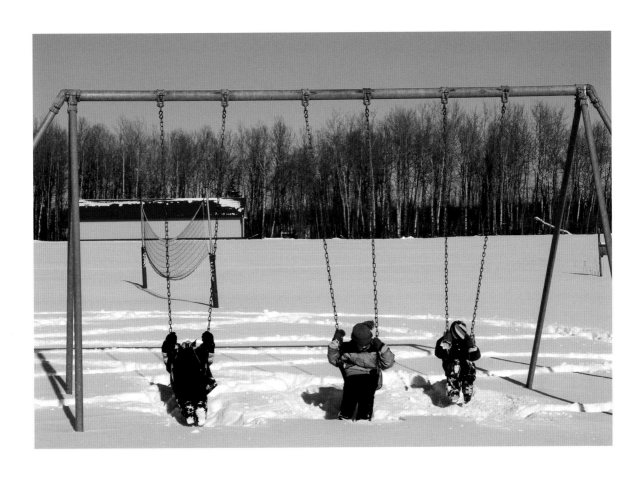

75

ABOVE Angle Inlet School, Northwest Angle, Lake of the Woods County

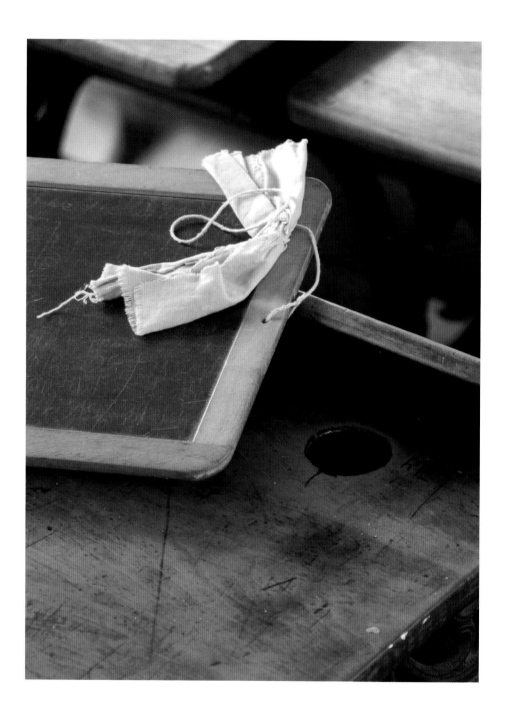

Not Such Good English

So I tells my friend, "We got these kids at my school from this one family, they don't talk such good English."

My friend, he says, "We got some of them at my school too. They don't talk such good English neither. They're called imgrints."

I tells my friend, "That's what they're called at my school too—imgrints with a funny accent, but you oughta hear them when they talk to each other, lots faster than American."

My friend, he says, "Those imgrints at my school, they study all the time. My mom says that's because they gotta catch up."

And I says, "That's what my mom says too, but she says these imgrints study so hard that they're going to pass me up in school if I don't watch out."

Then my friend, he says, "Our teacher, she says these new kids, they're bilingle, and the new kids smiled because they're bilingle. I don't know what bilingle means, but I'm pretty sure it ain't no American word. I think it's a bilingle word."

I tells my friend, "You're probably right, but why should we learn bilingle words? It's hard enought being borned here just to learn American."

LEFT AND ABOVE Stoen School, Gibbs Museum School

BELOW District 5, Beaver Falls Township, Renville County, 1871. The school was built for only two hundred dollars. After it closed in 1943, the school was used as a township hall.

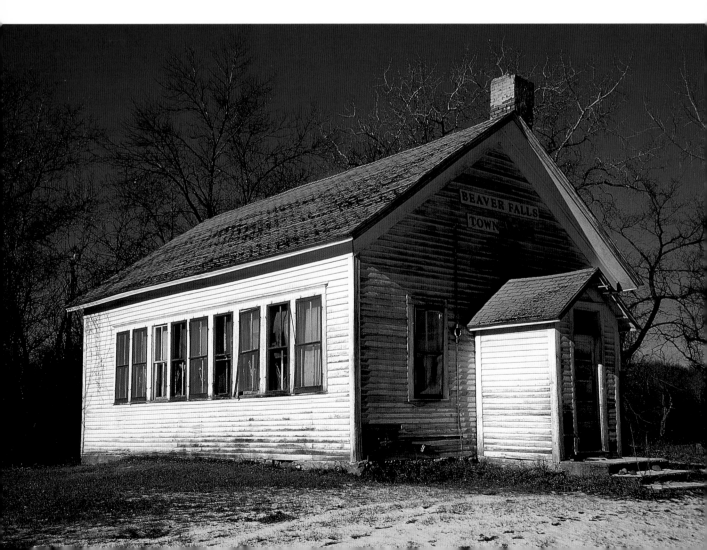

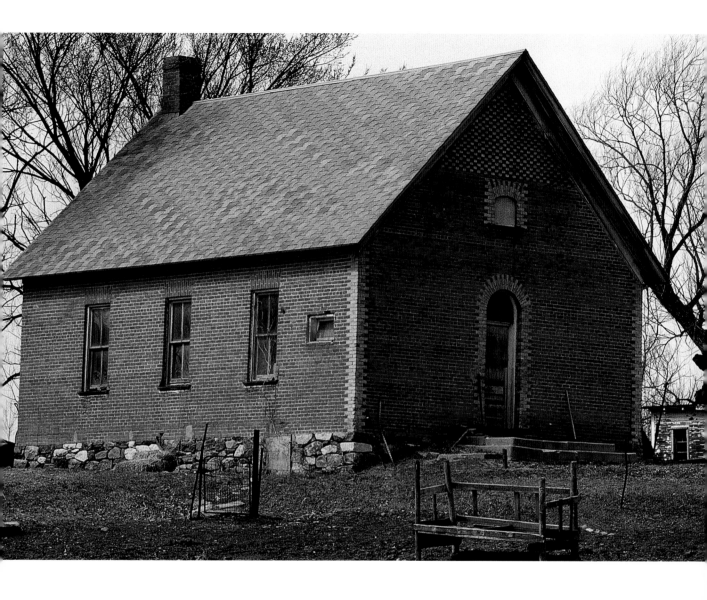

ABOVE District 28, Spring Lake Township, Scott County, 1888. Known locally as the Fish Lake School, it closed in 1941.

NEXT PAGES Class picture taken in 1934, District 98, Highland Township, Wabasha County. The school closed in 1943.

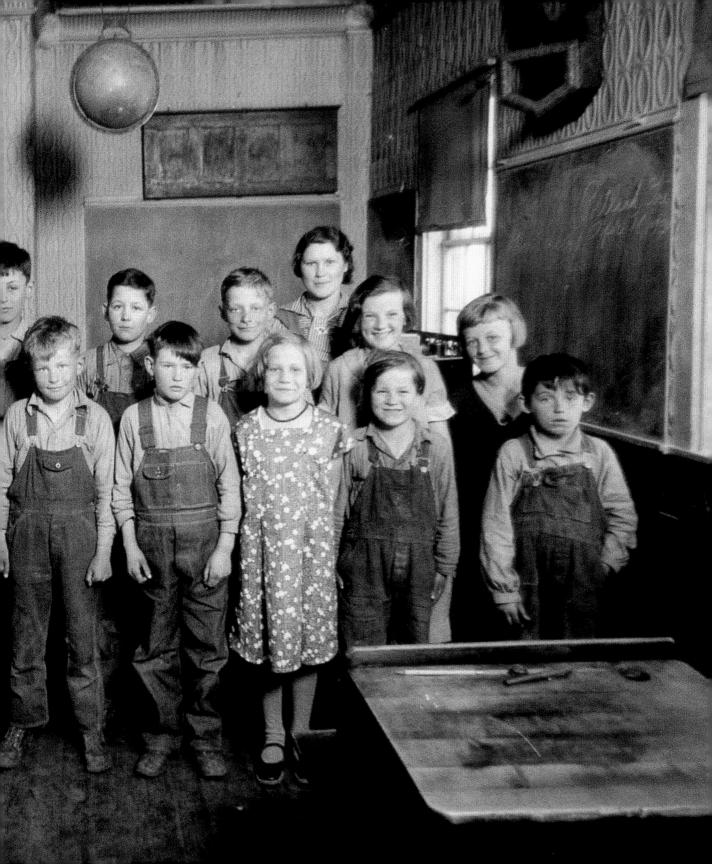

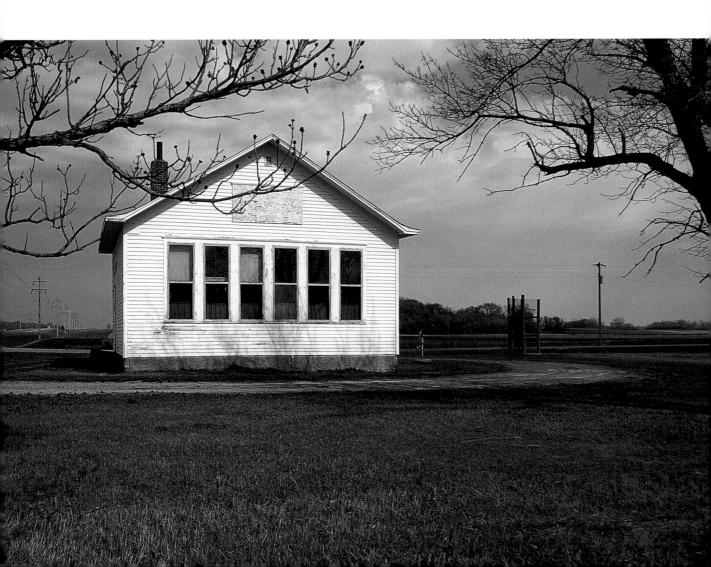

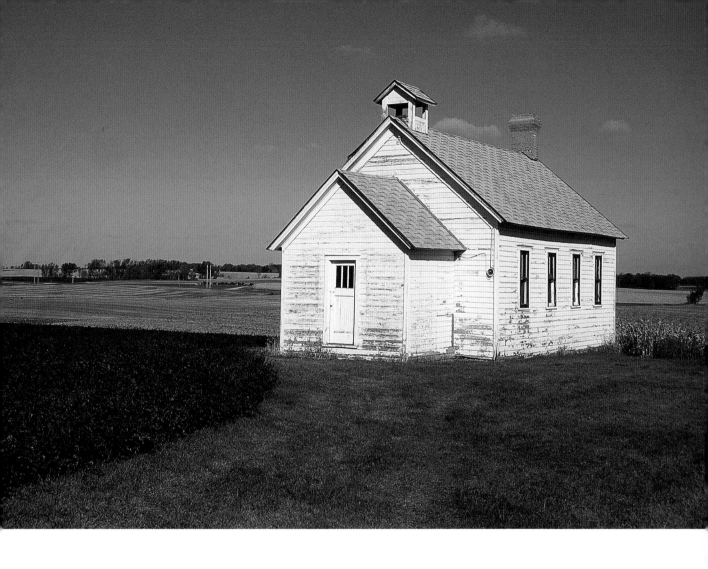

ABOVE District 18, Montgomery Township

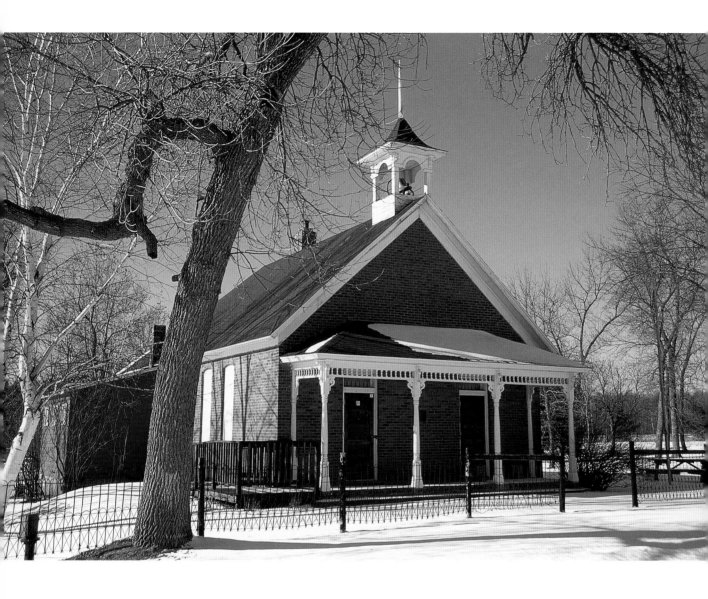

ABOVE Hay Lake School, New Scandia Township, Washington County, 1896, National Register. The school is now a museum operated by the Washington County Historical Society.

Central School, Grand Rapids Township, Itasca County, 1895, National Register

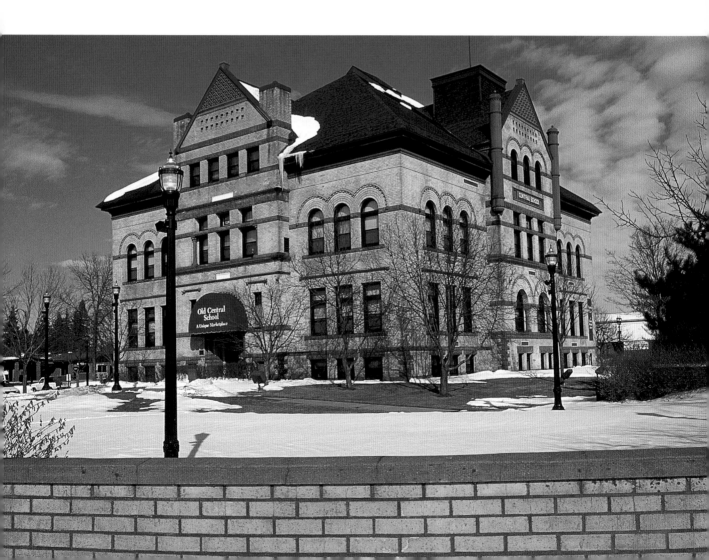

VvWwXxYyZz

School Ghosts

Just because you take the students out of the building. Just because you take out the desks, the books, the piano, the pictures of George Washington and Abraham Lincoln. Just because you perform an autopsy, a lobotomy, a disembowelment. Just because you gut the place and leave it to flutter like a corn husk in the wind, to flinch in the rain and hail, and to sag under the snow. Just because you think it's a castoff, a thing of the past. Just because you've done everything you can to declare it finished, caput, over the hill, vanquished, irrelevant, useless, it will not go away. It will just stand there, flaking shingles, losing siding, fading into a pale image of its old self. Transforming it, disguising it, letting weeds grow up around it—it will still be there, a schoolhouse. Turn it into a Town Hall, a Community Center, the Voting Place. Turn it into a house if you must. Turn it into a grain bin—or just let it stand to dry and sag and sigh in the wind. Do whatever you please with it, but something like destiny, some ancient plan of purpose, some deep-seated Original Meaning will go on living. It will still be a schoolhouse. Understand? Do you understand that? No matter what you do to it, it is still a

schoolhouse. Maybe it is only a shadow of its former self. Maybe it really is nothing more than a ghost, but there it is: A schoolhouse! A schoolhouse! Whoooooooooooooooooooooo. . . .

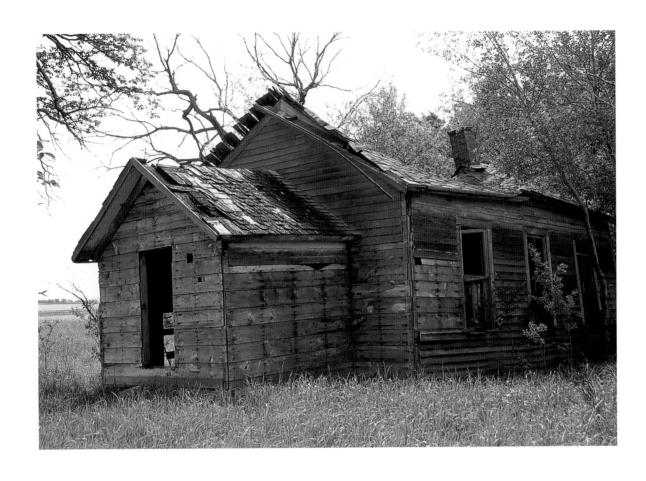

89

District 22, Tegner Township, Kittson County. Known locally as the Larson School.

Teacher's Pet

Everybody knows that Teacher's Pet is the teacher's pet for good reasons. Friendly, smart, helpful, obedient, courteous—you name it. Nobody can really fault the teacher for liking somebody who comes to class on time and sits up front at full attention the entire class period. Teacher's Pet does not spill milk, does not sneeze without using a handkerchief, does not color outside the lines, does not talk too loudly at lunch, and never never complains about teacher's assignments.

"Wow, that assignment was fun," says Teacher's Pet. "I really had to work hard but it was a very rewarding experience."

Did Teacher's Pet really say that— "a very rewarding experience?"

Teacher's Pet has a way of making the teacher smile and everyone else want to throw up.

During recess, out on the playground, the chain of command changes and Teacher's Pet runs into new rules.

When Teacher's Pet falls down, no hands reach out to help.

Look at Teacher's Pet be the last person chosen for anyone's team.

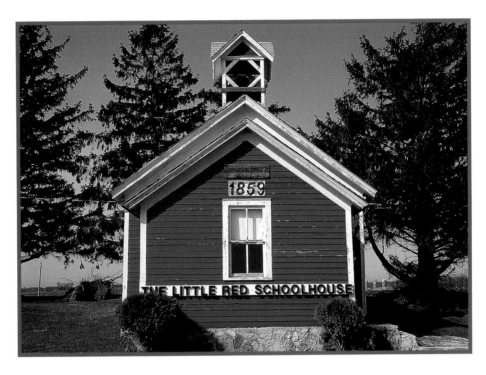

Look at Teacher's Pet get shoved out of the line to get on the slide.

And notice how quiet Teacher's Pet is out on the playground.

Back in school after recess, when teacher asks if everyone had a good time, Teacher's Pet speaks up quickly: "Oh, yes," says Teacher's Pet. "I had a great time, thank you."

ABOVE District 49, Zumbro Township, Wabasha County. Laura and Mary Ingalls attended school here for a few months.

The Class Gerbil

If we get a gerbil, who will feed it?

I will!

I will!

I will!

If we get a gerbil, who will clean out its cage?

I will!

I will!

I will!

If we get a gerbil, who will hold it and make it feel loved?

I will!

I will!

I will!

Has anyone fed the gerbil?

Has anyone cleaned its cage?

Has anyone held it and made it feel loved?

I have!

I have!

I have!

92

RIGHT District 13, Artichoke Township, Big Stone County, 1898, National Register. The school cost eight hundred dollars to construct and served county students until 1955.

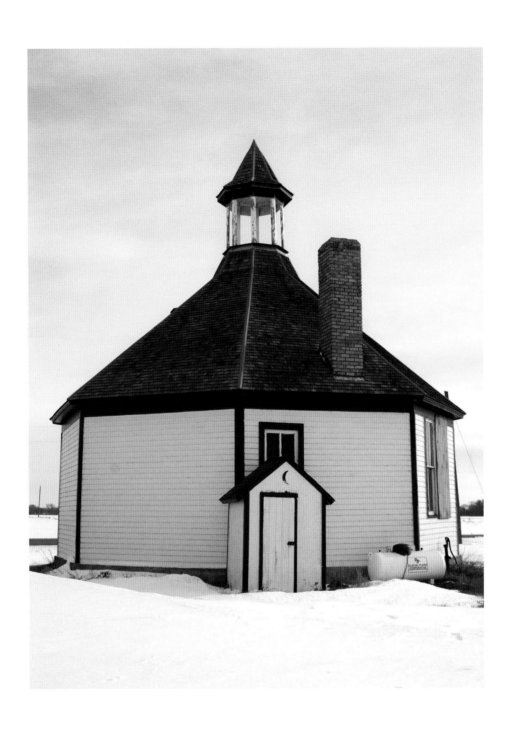

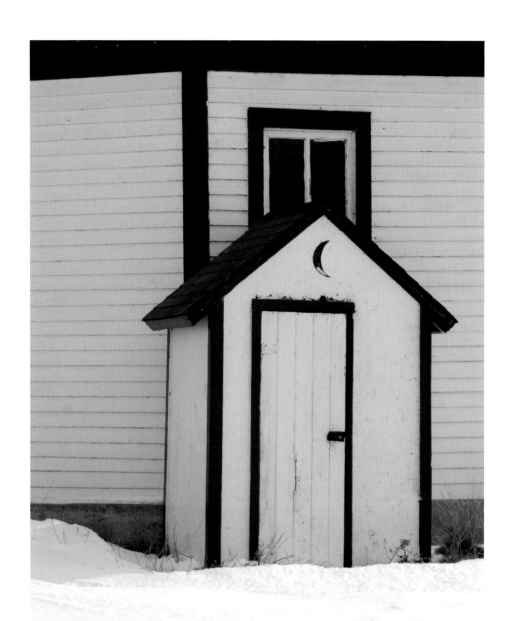

Headlights

"Teacher said I had to come home because I have headlights."

Head lice: itching is believing.

Head lice: one way to make people keep their distance.

Head lice: you can't trust anybody.

Head lice: they make bald people attractive.

Head lice: they make everybody a nitpicker.

Head lice: you don't have to have them to feel them.

Blame somebody's cousin who visited from Florida. Blame the family with thirteen kids and one bathroom. Blame thrift stores. Blame the prissy kids who don't want to mess up their hair by washing it. Blame the school for being so old and dusty. Blame the neighbor's dog. Blame the teacher. Blame global warming. Blame the government.

"Headlights? No, but we'll need flashlights."

Undoing a misunderstanding does not solve the problem. Head Lice. That great equalizer, striking the just and unjust unlike, ignoring race, religion, gender, and personal hygiene.

"But Mommy, why are you boiling my clothes?"

95

BELOW District 127, Oscar Township, Otter Tail County, 1880. Known locally as the Hillside School, it closed in 1966.

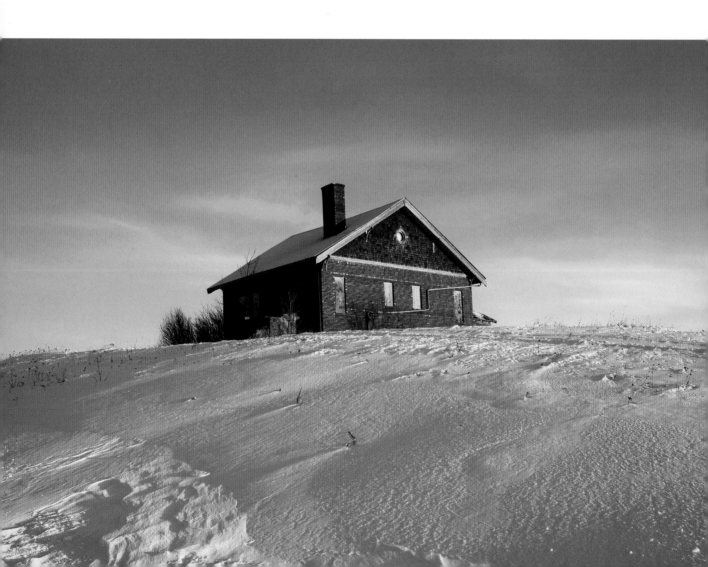

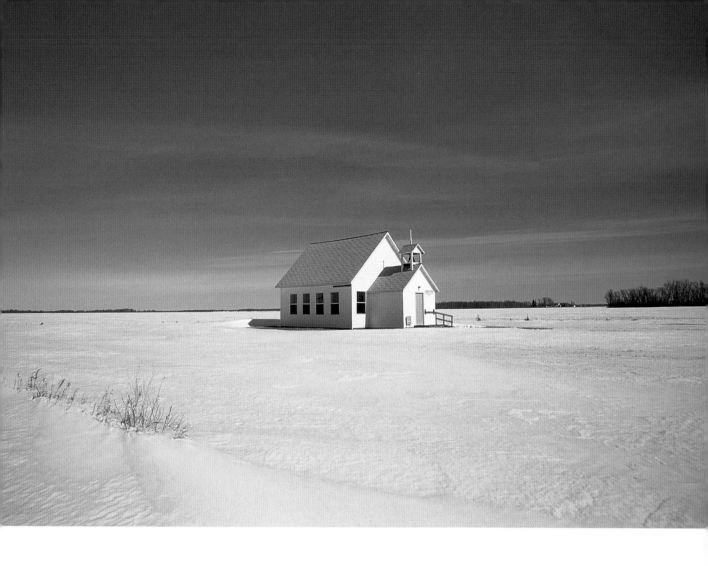

ABOVE Reiner School, Reiner Township, Pennington County. The school is now used as the Reiner Township Hall.

NEXT PAGES Danebod (Danish) Folk School, Hope Township, Lincoln County, 1904, National Register

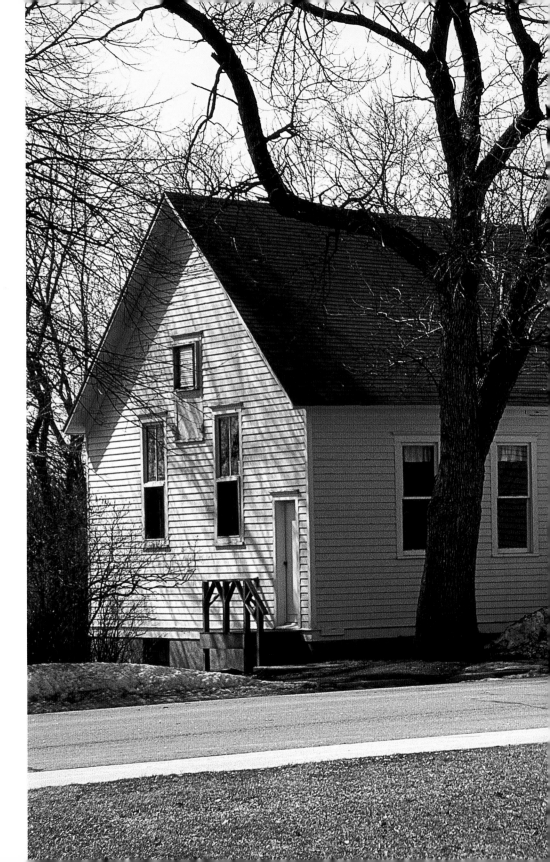

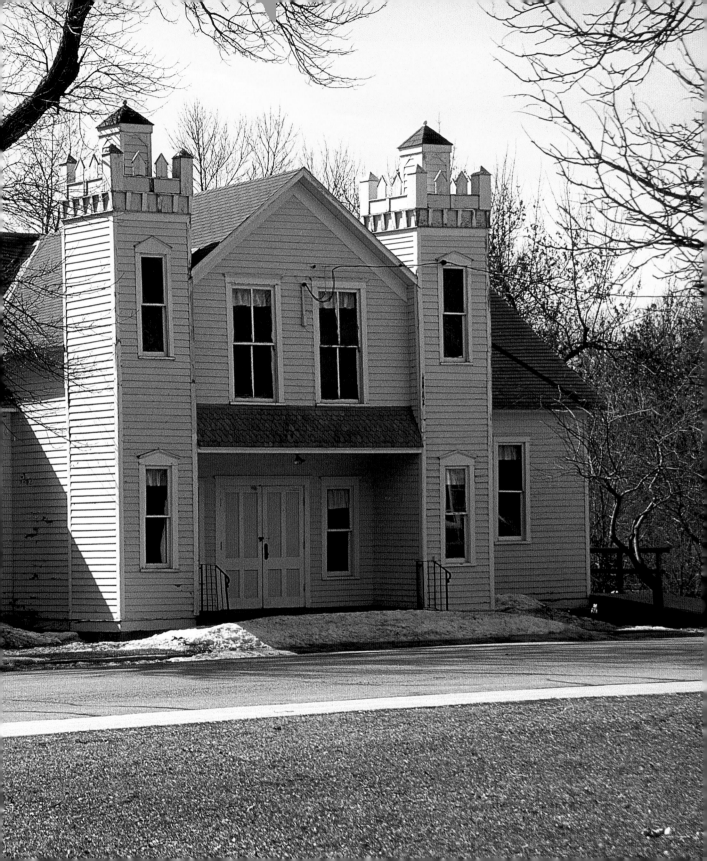

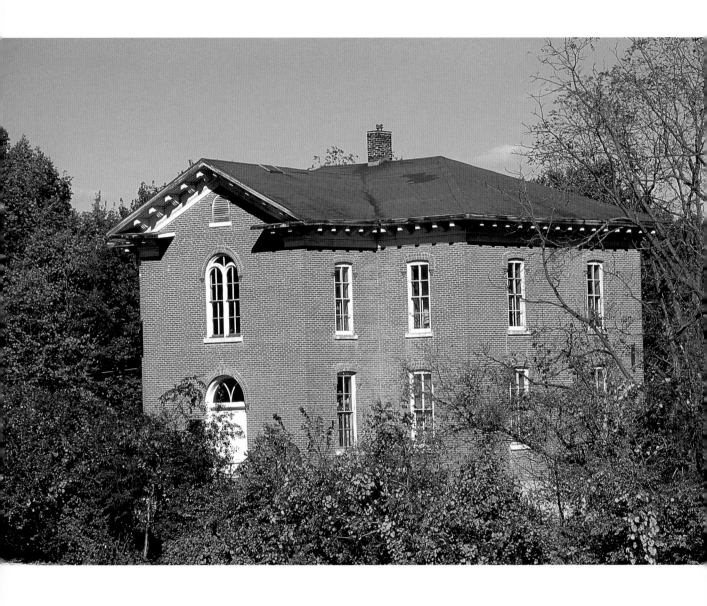

ABOVE Oronoco School, Oronoco Township, Olmsted County, 1875, National Register. The school has fourteen rooms with a circular stairway leading to two upstairs ballrooms.

District 100, Haverhill Township, Olmsted County. The district was organized in 1862.

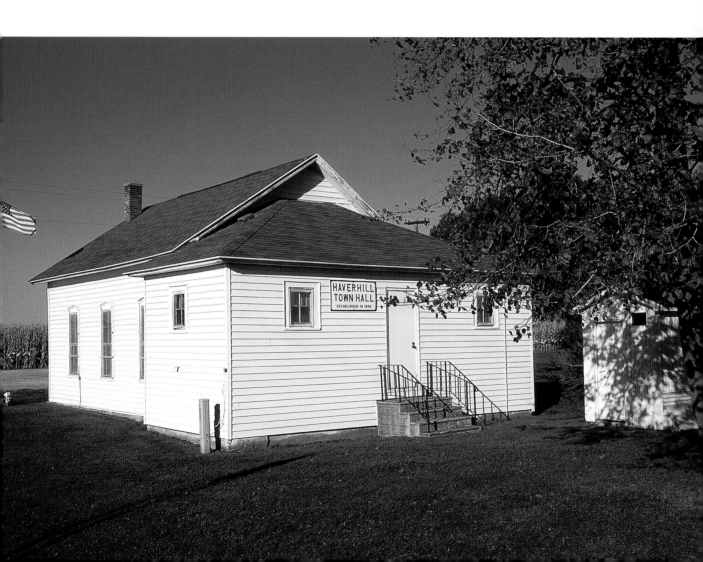

Smells

Old schools are an archeology of smells. We could write a school's history if we brought back the smells.

A 1920s smell of Prince Albert pipe tobacco lingers in the walls of one country schoolhouse. It is probably not a lie: the story of the wise and bearded teacher who smoked his pipe as he taught, striking his farmer's match on his desk, lighting his S-shaped pipe, blowing out the match and using it as a pointer on the blackboard—with blue smoke curling over his head, tapping on each word for the first-graders: "'a' as in c*a*t and b*a*t and f*a*t."

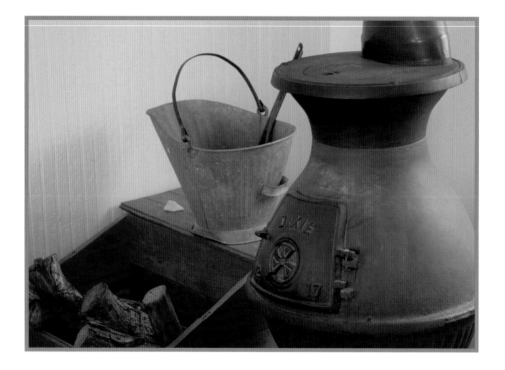

ABOVE Stoen School, Gibbs Museum School

Before electrical power lines, kerosene lanterns hung from schoolhouse ceilings, some leaving dark spots on the ceiling and a lingering odor of kerosene. If you're old enough, you'll remember what you were reading on dark winter mornings when the letters in your reading book came alive on paper designed for yellow kerosene light. The same schools will have lingering smells of coal, smells that tell the same story as the black dust you see on the rafters.

And here come the unforgettable smells of oily sweeping compound that kept hardwood schoolhouse floors clean and glossy through the 1940s and '50s. Can the smell of Elmer's glue, Wildroot hair cream, ditto machine fluid, and Magic Markers be far behind?

The Paste Eater

In the good old days of quart-sized jars of washable white paste, no school was complete without a paste eater. The paste eater was better than the kid who came to school with different colored socks on each foot or the one who liked to display his huge collection of bottle caps. The paste eater offered a higher level of entertainment than the blank-stared daydreamer or the long-fingered nose picker. Truth is, the paste eater was an addict, addicted to a totally nonaddictive substance, white school paste.

The paste eater would hide his addiction behind modest finger licking while pasting cutouts onto construction paper, no more conspicuous than a social drinker at a wedding. He tried to appear very normal when an open jar of paste was placed on the table: anybody might take a sip or two of paste from the tips of their fingers. But the jar of paste was like a magnet to him. He sat as close as he could to that big open jar. He couldn't keep his eyes off it. Then he'd slip past the normal indicators by dunking two or three fingers into the jar, pulling them out and looking surprised at how totally slathered his fingers were, and then going for the paste as if it were birthday cake frosting. The paste eater might have gotten by with his addiction if he could have controlled himself, if he could have continued behaving like a normal social paste taster with a lick here and a lick here. But for the paste eater, it was all or nothing. To many students, the paste eater was repulsive. "How disgusting!" one would say. But a few would say admiringly, "Wow! He sure can hold his paste."

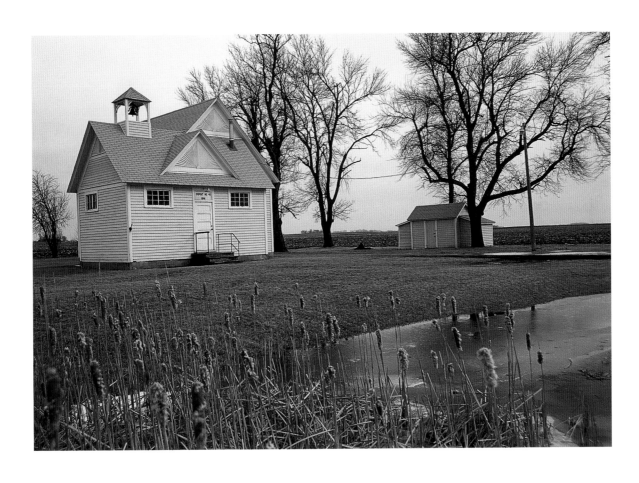

ABOVE District 40, Walnut Lake Township, Faribault County, 1875, National Register. The school is known locally as the Pink School.

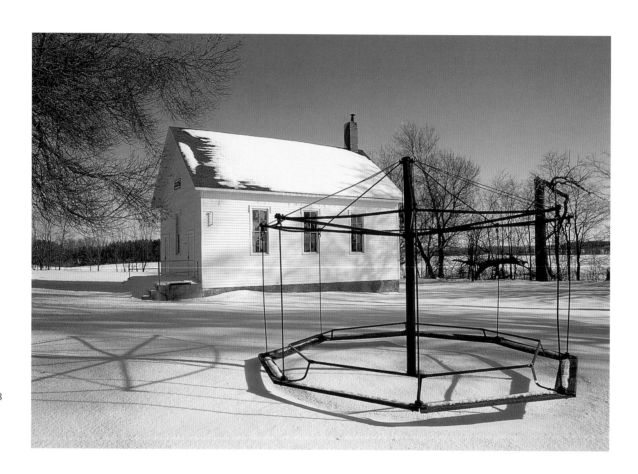

108

Merry-go-round

What you know when you're on the merry-go-round:

The one on the ground has the power to fling others into space.

Centrifugal force is one thing, but dizziness is the real challenge.

Falling off just means that you get the chance to push.

You can stay on if you lean forward but it's more fun to lean back
and feel the pressure.

Holding on with only one hand and screaming is a good way
to make friends.

Being the only one who faces out, smiling, makes the rest of
the day easy.

Many years later it occurs to you that

Being the one on the ground pushing prepared you for parenthood.

Being the one who faced out prepared you for politics.

Hanging on with only one hand prepared you to marry three times.

Screaming while twirling prepared you to host many dinner parties.

Leaning safely forward prepared you to balance your checkbook.

Tolerating dizziness prepared you for fools in the workplace.

Thinking that every time on the merry-go round was a good time
prepared you to kid yourself about the past.

Auctioning Off the Schoolhouse

This is the story of a boy who knew the one-room schoolhouse was going to be sold at auction next week.

Everybody knew that some things just shouldn't be sold. Would they auction off a library? Would they auction off a church? Well, maybe some people would, but how could anybody auction off a schoolhouse just because everybody was going to the consolidated school? Didn't grandfathers save the toy tractors they had as little kids so they could show their grandkids how things used to be?

This wasn't even the first schoolhouse around there to be auctioned off. The farmer who bought the last one turned it into a grain bin. He filled

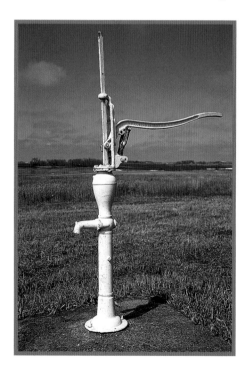

it too full of shelled corn and the sides burst out, something that never would have happened from having too many kids or books inside. Another schoolhouse was used by the town fire department for practice. The whole neighborhood came to watch that one: how they tortured the schoolhouse by lighting it, putting it out, lighting it, and putting it out again—over and over until the schoolhouse sighed its last mouthful of smoke and everyone left.

The boy went to have a last look at the schoolhouse before the auction. He kicked

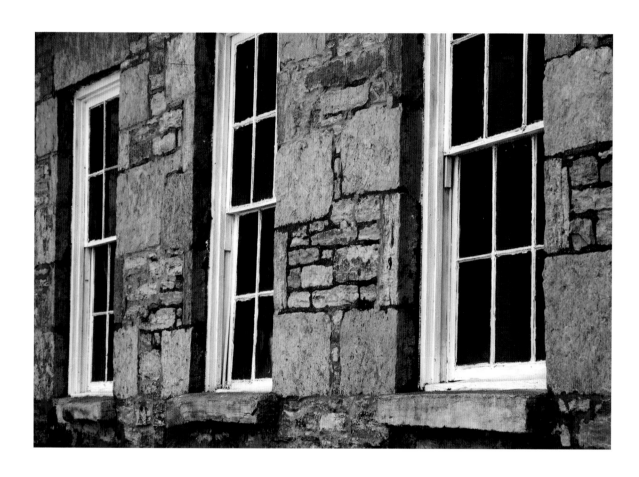

LEFT Water pump, rural Pipestone County. Last visible reminder of the school site.

ABOVE Jordan Township, Fillmore County

112

the coal door—that secret coal-door kick—and it popped open. Inside, he checked out the out-of-tune piano and looked at the old desks that had sixty years worth of initials carved on them. He found his father's initials, but not his mother's. He opened the door to the little library that was the size of a clothes closet. He pulled out the bottom drawer of the teacher's desk to find the answer keys to history, English, and arithmetic books that nobody wanted the answers to anymore. Next to the desk stood the long recitation bench, and up front was

the dictionary stand. On the wall above the blackboard hung a dusty picture of George Washington.

It would have been easy to steal some things before the auction, just steal them and put them in a good place where nobody would find them. Instead, the boy went home for the camera. He could take pictures of every-thing—inside and outside. But the boy's allowance was small, and there wasn't time to save enough money for film before the auction. I'll just have to remember what the schoolhouse looked like, he figured, in case some-body ever wants to know.

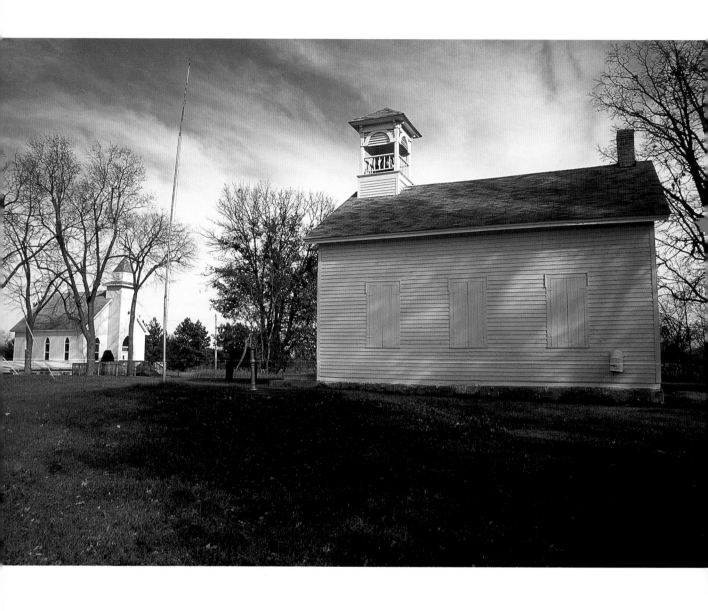

ABOVE District 1, Spencer Brook Township, Isanti County, 1877, National Register. It was the first school in Isanti County.

BELOW District 44, Taylor Township, Traverse County, 1900. The school closed in 1953 with the last enrollment of only twelve students.

NEXT PAGES Sioux Agency Township, Yellow Medicine County

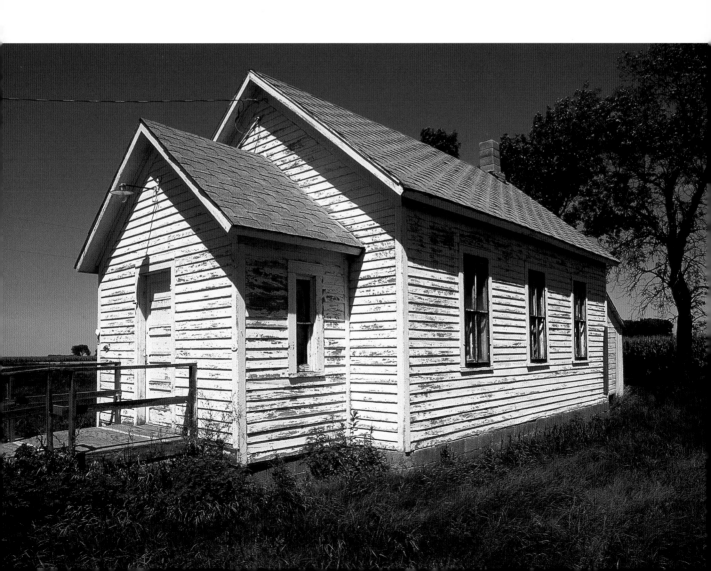

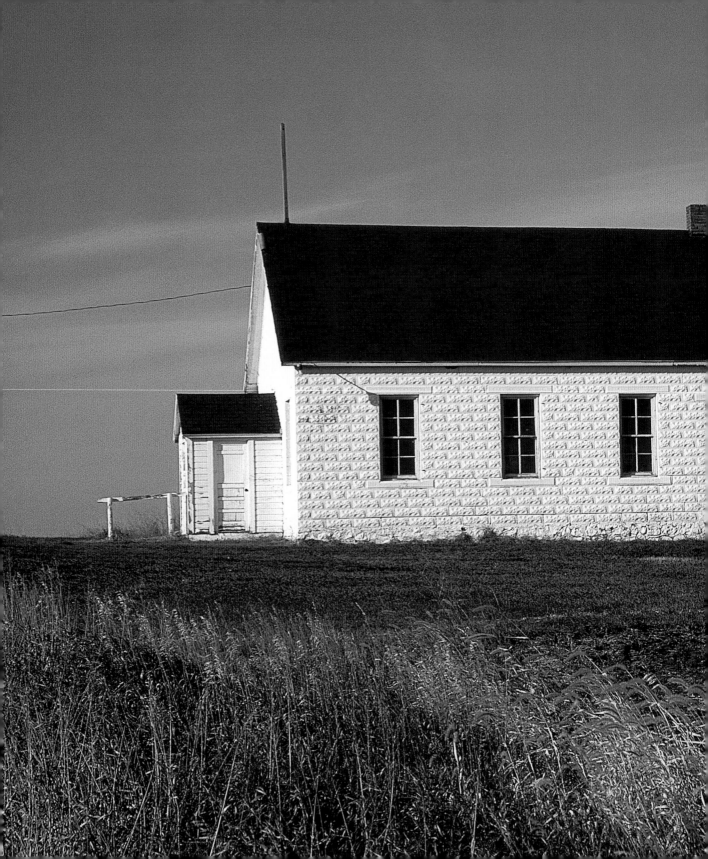

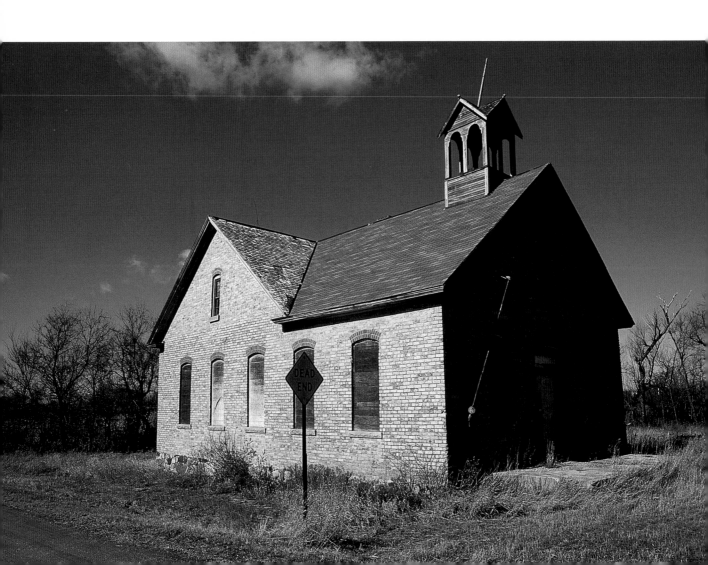

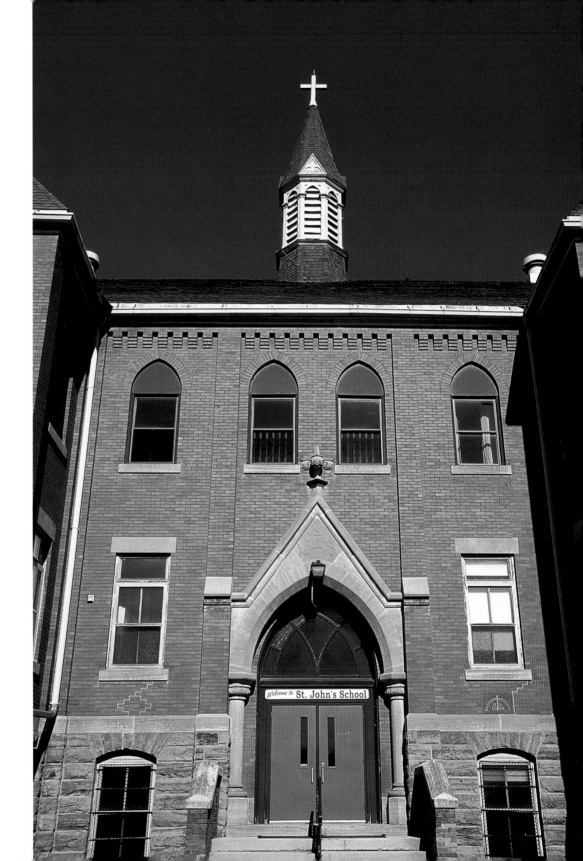

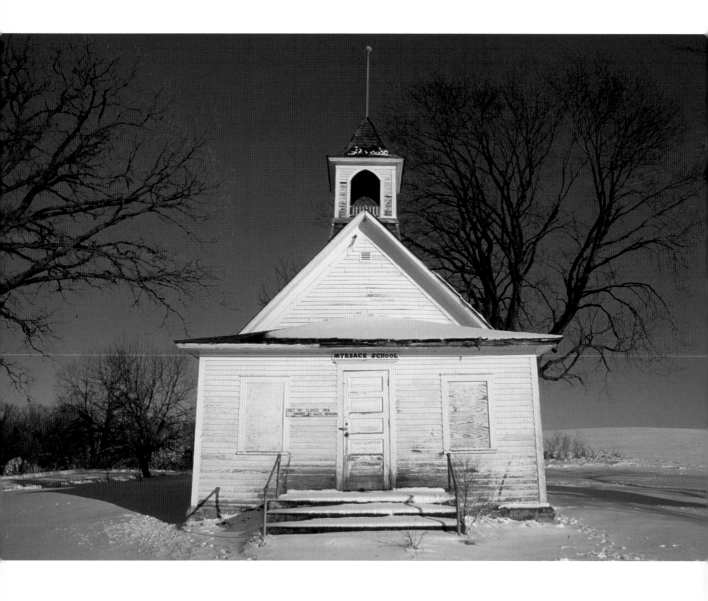

ABOVE District 110, Myrbeck School, Marysville Township, Wright County. The school closed in 1958.

Bell tower, Hay Lake School, New Scandia Township

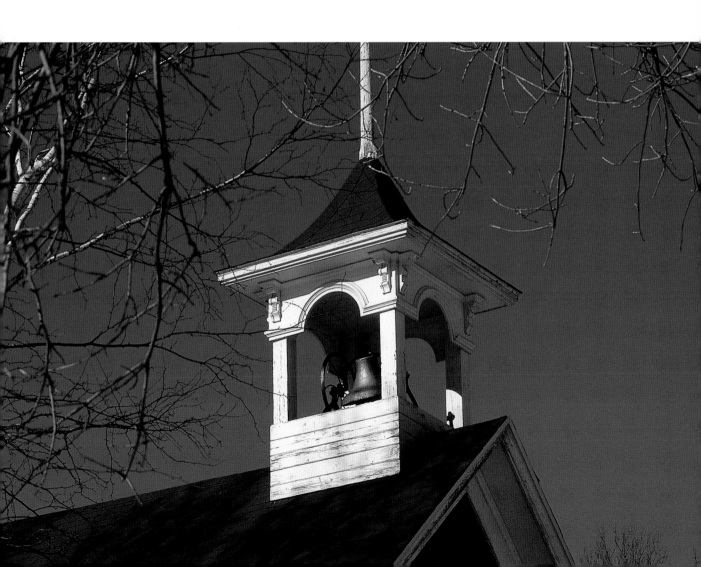

The Last One-room Schoolhouse in Minnesota

Instead of a pony's whinny, a snowmobile's whine from the playground;
instead of the kerosene lantern's dim yellow, the computers' blue glow
through the windows; and instead of the flapping door of an outhouse,
the flush and warm water of the in-house toilet—but what really counts
has not changed.

Inside, one teacher faces all grades, one teacher makes lesson plans
for all students in all subjects, and one teacher watches her students grow
from First to Eighth. The school building is still so small that there's no
room to hide your secrets. Anybody's fight is everybody's fight, and helping

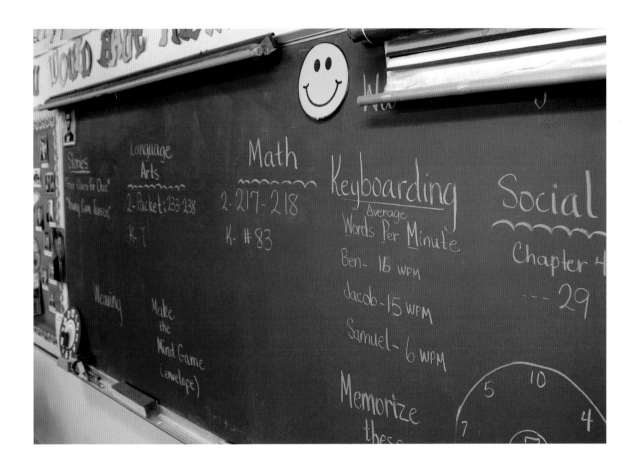

LEFT Angle Inlet School, the last remaining one-room schoolhouse in Minnesota. The current teacher commutes to school on a snowmobile in the winter and by fishing boat in the spring and fall.

ABOVE The day's work, Angle Inlet School

each other makes more sense than proving who's best. Little kids listen to all grades being taught above them and older kids review all grades below them. Have a bad year in grade 5? You can review it while you're in grades 6 and 7. Tired of the pace of grade 2? Tune in to what's happening with the seventh-grade math. Cooperative learning? Peripheral learning? Big schools with big classes might watch and take note.

The last one-room schoolhouse in Minnesota is an old-fashioned unit of learning, with the older teaching the younger and the younger learning from the older, where one person's concern is everyone's concern. The sailor's motto follows this small ship as it sails along through the uncertain waters of the twenty-first century: "One for all and all for one."

ABOVE Recess, Angle Inlet School

Photographer's Note

Photographing for *Schoolhouses of Minnesota* has been a real privilege and honor. This photographic journey has taken me throughout Minnesota, but more importantly it has taken me into the lives of many who recall with great fondness their experiences attending country school. With only one notable exception, the Angle Inlet School in the Northwest Angle, the experience of all grades in one room—playing fox-and-goose at recess, or walking across snow-drifted fields to school—are all fading memories. My goal in this book is to preserve these memories so that future generations can, in some small way, learn about and enjoy a wonderful slice of history.

My personal memory of a schoolhouse comes from the photo shown here. It is of the historic schoolhouse in Anoka County where my father and mother voted in the 1968 presidential election. Dad voted for Hubert Humphrey and Mom for Richard Nixon. I recall waiting in the car for them and listening to them laugh on the drive home about their votes canceling each other.

My thanks go to the many folks who over many cups of coffee shared their schoolhouse stories with me. I also appreciate my editor Pamela McClanahan and the staff at the Minnesota Historical Society Press for seeing the importance of this project. And finally, thanks to my wife Krin and children Emily and Matthew for their unending encouragement.

DOUG OHMAN
New Hope, Minnesota

ABOVE District 28, Ramsey Township, Anoka County, 1892, National Register

List of Schoolhouses

COUNTY/SCHOOL	CITY/TOWNSHIP	PAGE
AITKIN COUNTY		
District 8	Kimberly Township	29
ANOKA COUNTY		
District 28	Ramsey Township	125
BECKER COUNTY		
—	Height of Land Township	62
BIG STONE COUNTY		
District 13	Artichoke Township	37, 93, 94
CARVER COUNTY		
St. Bernard Catholic School	Cologne, Benton Township	64–65
CASS COUNTY		
—	Maple Township	30–31
CHIPPEWA COUNTY		
—	Rosewood Township	82
District 27 (Leenthrop School)	Leenthrop Township	38
CLAY COUNTY		
District 121 (Gunderson School)	Moland Township	63
COTTONWOOD COUNTY		
District 48	Rose Hill Township	2–3
CROW WING COUNTY		
District 81 (Swanburg School)	Timothy Township	13
DODGE COUNTY		
District 38	Mantorville Township	28
FARIBAULT COUNTY		
Delavan School	Delavan Township	61
District 40 (Pink School)	Walnut Lake Township	107
FILLMORE COUNTY		
—	Jordan Township	111
—	Rushford Township	73
GOODHUE COUNTY		
District 20	Hay Creek Township	66
District 32	Belvidere Township	50
Wangen Prairie Lutheran School	Leon Township	10–11
HENNEPIN COUNTY		
District 17	Burschville Township	19
Hiawatha Community School	Minneapolis	36
Pratt School	Minneapolis	23, 47

ISANTI COUNTY
District 1 — Spencer Brook Township — 114

ITASCA COUNTY
Central School — Grand Rapids Township — 85

JACKSON COUNTY
District 133 — Hunter Township — 26

KANABEC COUNTY
District 14 (Webster School) — Comfort Township — 16–17

KITTSON COUNTY
District 22 (Larson School) — Tegner Township — 89

LAKE OF THE WOODS COUNTY
Angle Inlet School — Northwest Angle — 75, 122–24

LE SUEUR COUNTY
District 18 — Montgomery Township — 67, 83

LINCOLN COUNTY
Danebod (Danish) Folk School — Hope Township — 98–99

MAHNOMEN COUNTY
— — Bejou Township — 51

MC LEOD COUNTY
District 70 — Bergen Township — 118

MILLE LACS COUNTY
District 43 (Whitney Brook School) — Page Township — 57

MOWER COUNTY
District 106 (Maple Leaf School) — Dexter Township — 9, 45

NICOLLET COUNTY
District 6 — New Sweden Township — 12

OLMSTED COUNTY
District 82 — High Forest Township — 6
District 100 — Haverhill Township — 101
Oronoco School — Oronoco Township — 100

OTTER TAIL COUNTY
District 54 (Sunshine Hill School) — Fergus Falls Township — 25, 33
District 127 (Hillside School) — Oscar Township — 96

PENNINGTON COUNTY
Reiner School — Reiner Township — 97

PINE COUNTY
District 74 (Danforth School) — Danforth Township — 39

POLK COUNTY
— Gully Township 41

POPE COUNTY
District 27 Terrace Township 27
District 72 Reno Township 18
District 94 Blue Mounds Township 44

RAMSEY COUNTY
District 28 (Wilder School bus) — 60
St. Matthew's Catholic School St. Paul 54
Stoen School (Gibbs Museum School) — 71, 76, 77, 104, 112

REDWOOD COUNTY
District 10 (Swedes Forest School) Swedes Forest Township 48–49

RENVILLE COUNTY
District 5 Beaver Falls Township 78

RICE COUNTY
District 15 (Little Prairie School) Bridgewater Township 108

SCOTT COUNTY
District 28 (Fish Lake School) Spring Lake Township 79
St. John's Catholic School Jordan, Sand Creek Township 119

SIBLEY COUNTY
St. John's Lutheran School Bismarck Township 32

STEARNS COUNTY
District 136 (Gray's School) Ashley Township 8

STEELE COUNTY
District 35 (Schmanski School) Lemond Township 24
Owatonna High School Owatonna 46

STEVENS COUNTY
District 11 Donnelly Township 43

TRAVERSE COUNTY
District 44 Taylor Township 115

WABASHA COUNTY
District 49 Zumbro Township 91
District 98 Highland Township 80–81

WASHINGTON COUNTY
Hay Lake School New Scandia Township 84, 121

WRIGHT COUNTY
District 110 (Myrbeck School) Marysville Township 120

YELLOW MEDICINE COUNTY
— Sioux Agency Township 116–17